FANTASY FLOWERS
COLORING BOOK
No. 2

by -Alberta Hutchinson-

Copyright © 2014 by Alberta Hutchinson
All rights reserved

ISBN: 978-1493504916

Series:

Published by:

An Imprint of

Illume Writers & Artists

P.O. Box 86
Gilbertsville, New York 13776

Printed in the United States of America

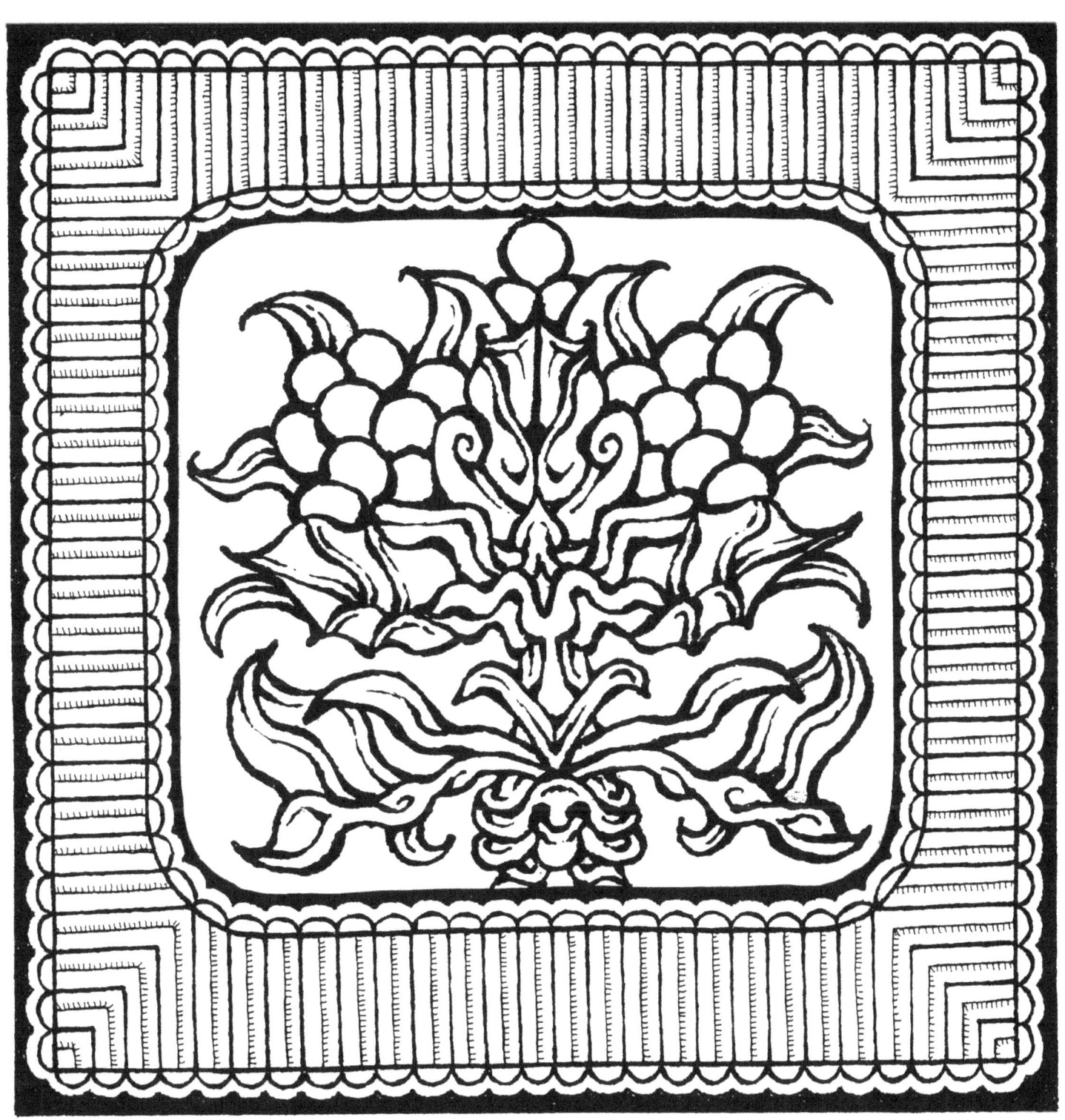

Cut out this page to use as backing, to prevent bleed-through to subsequent pages

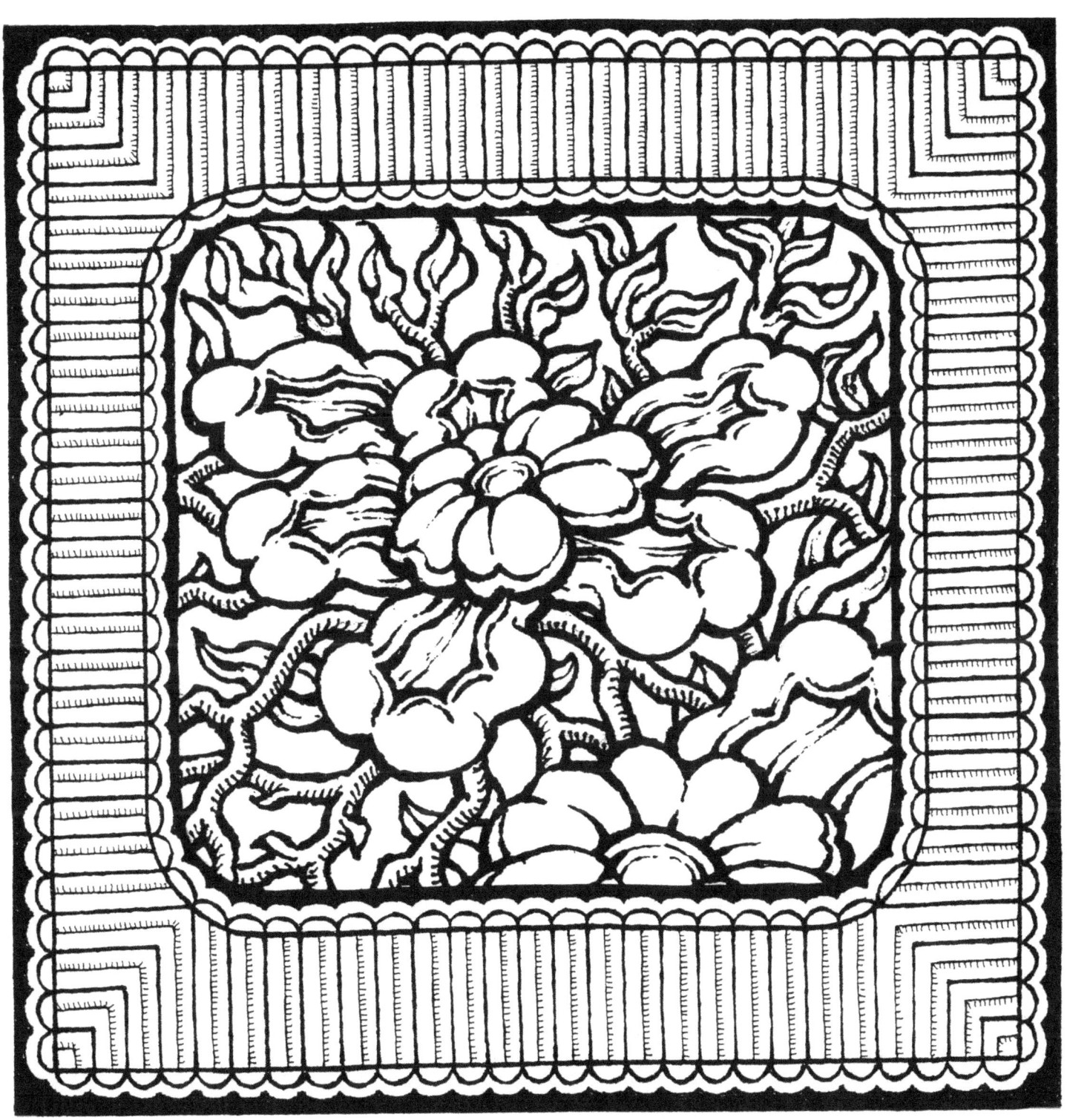

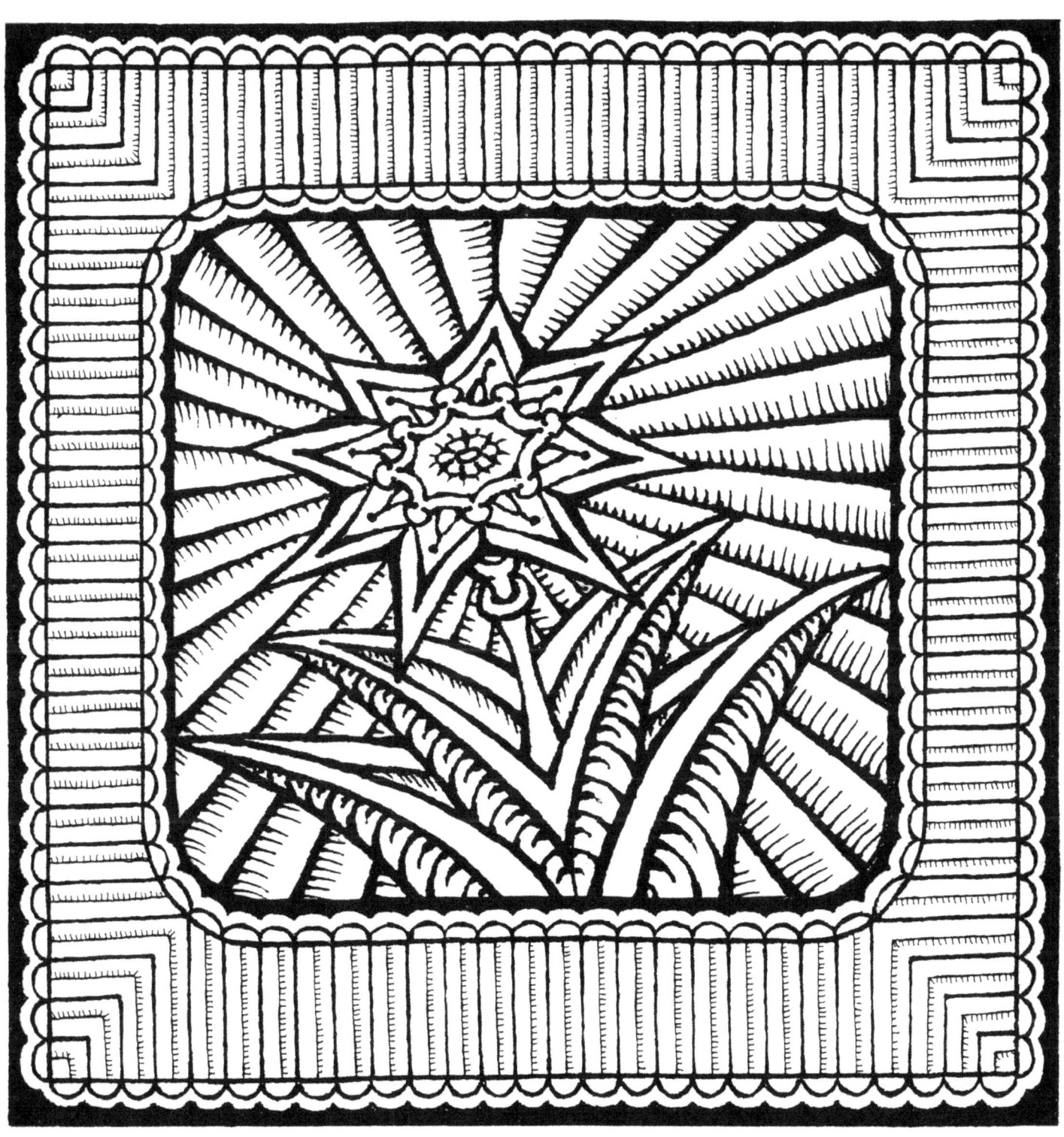

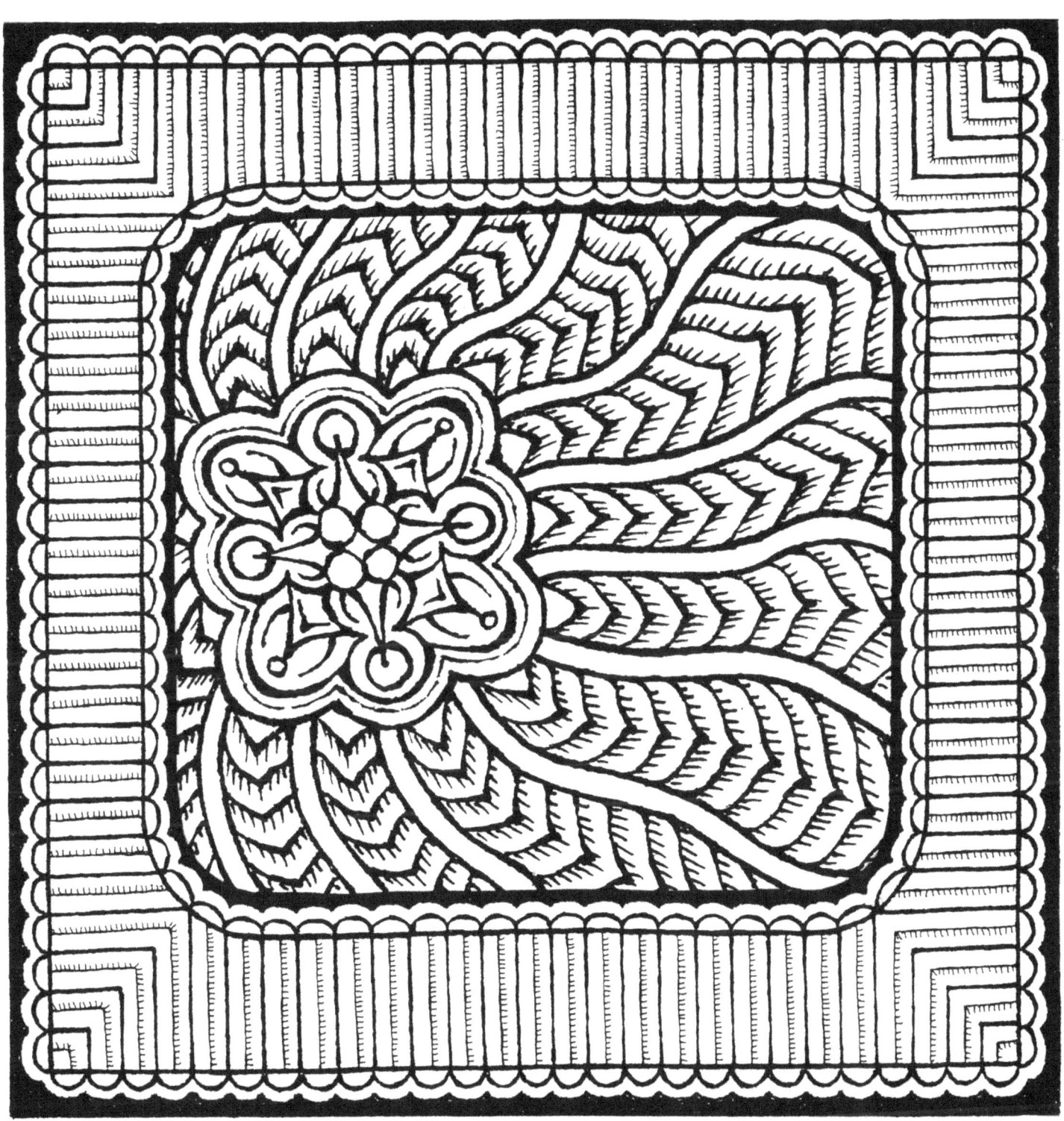

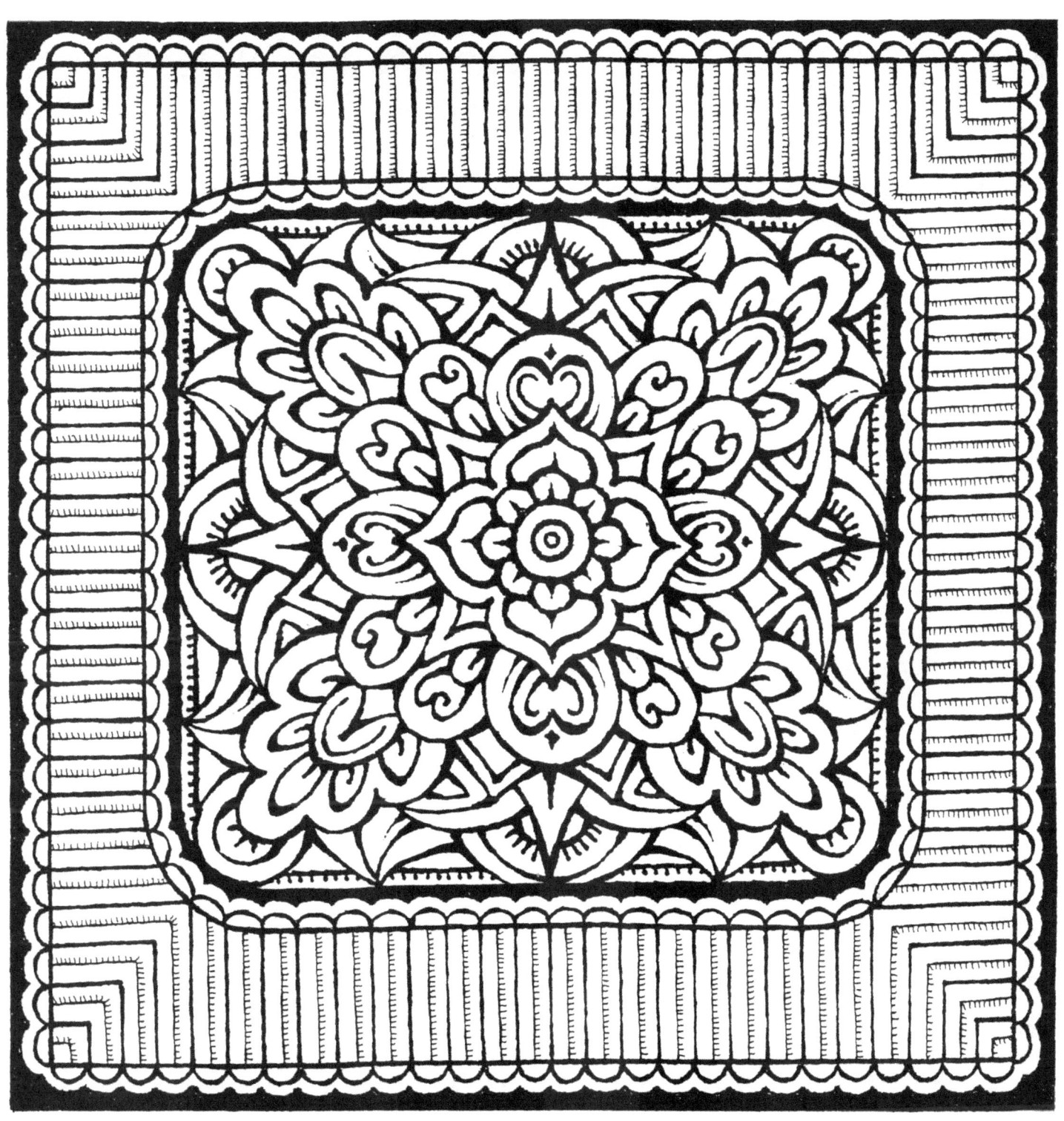

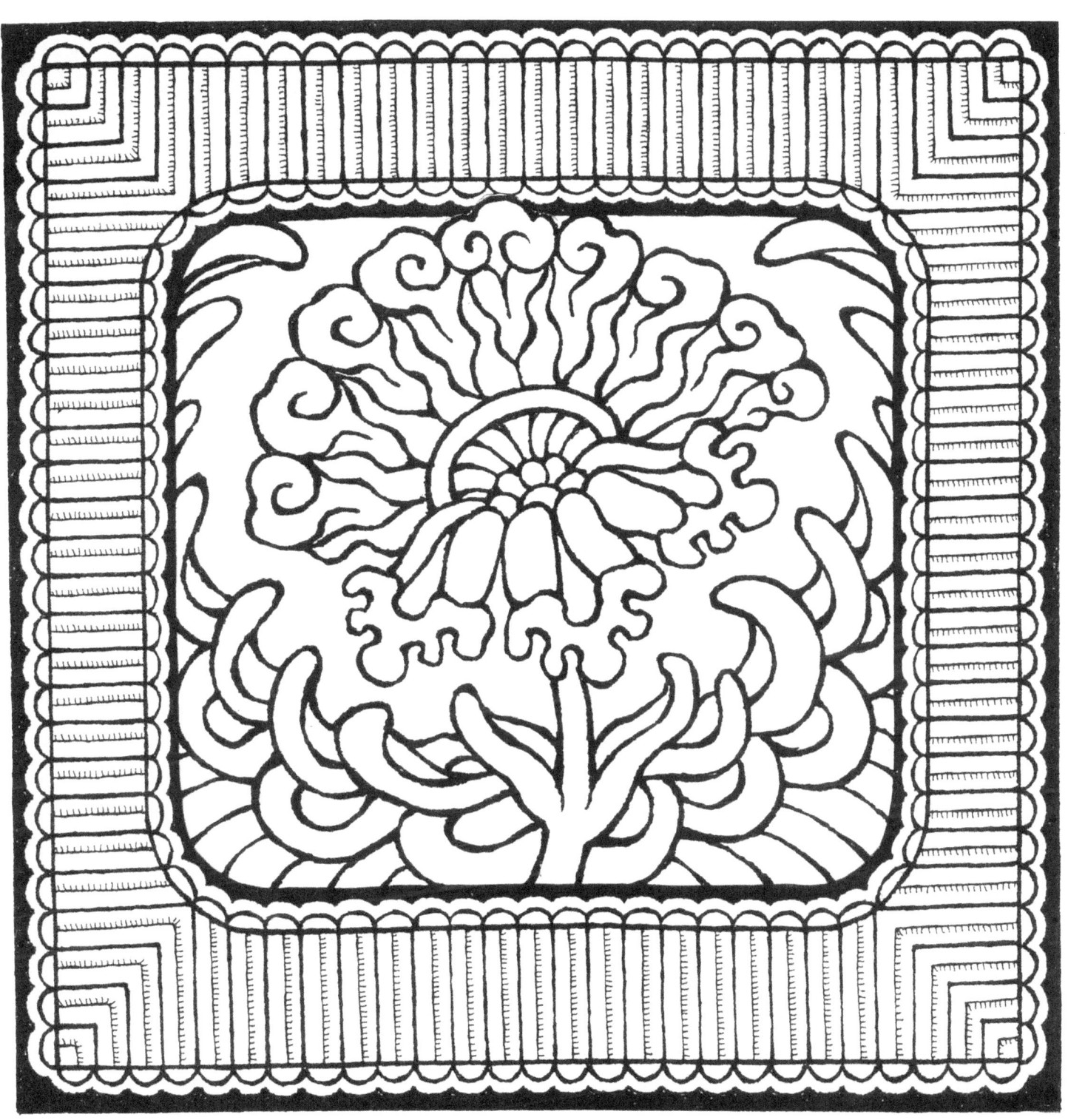

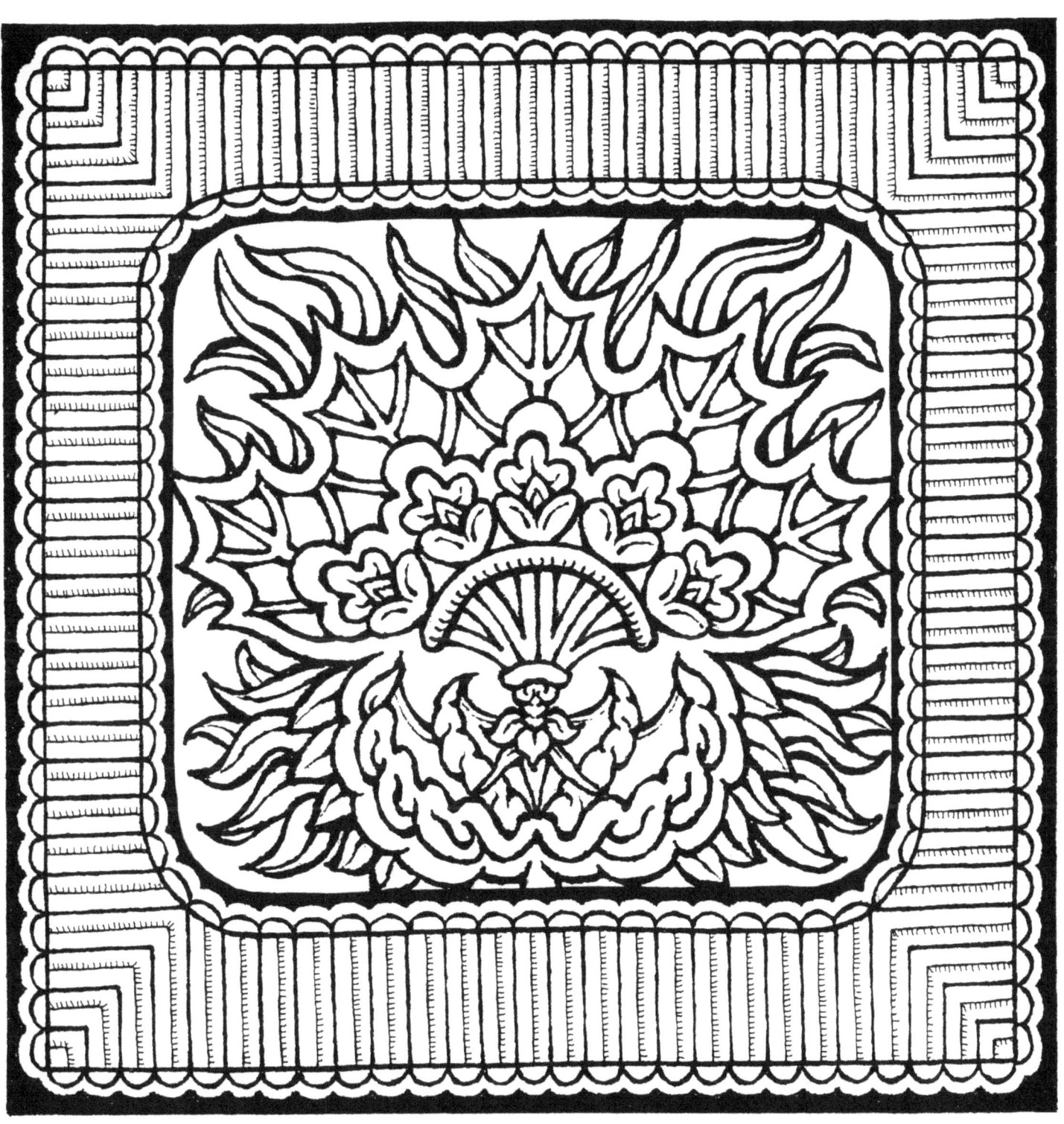

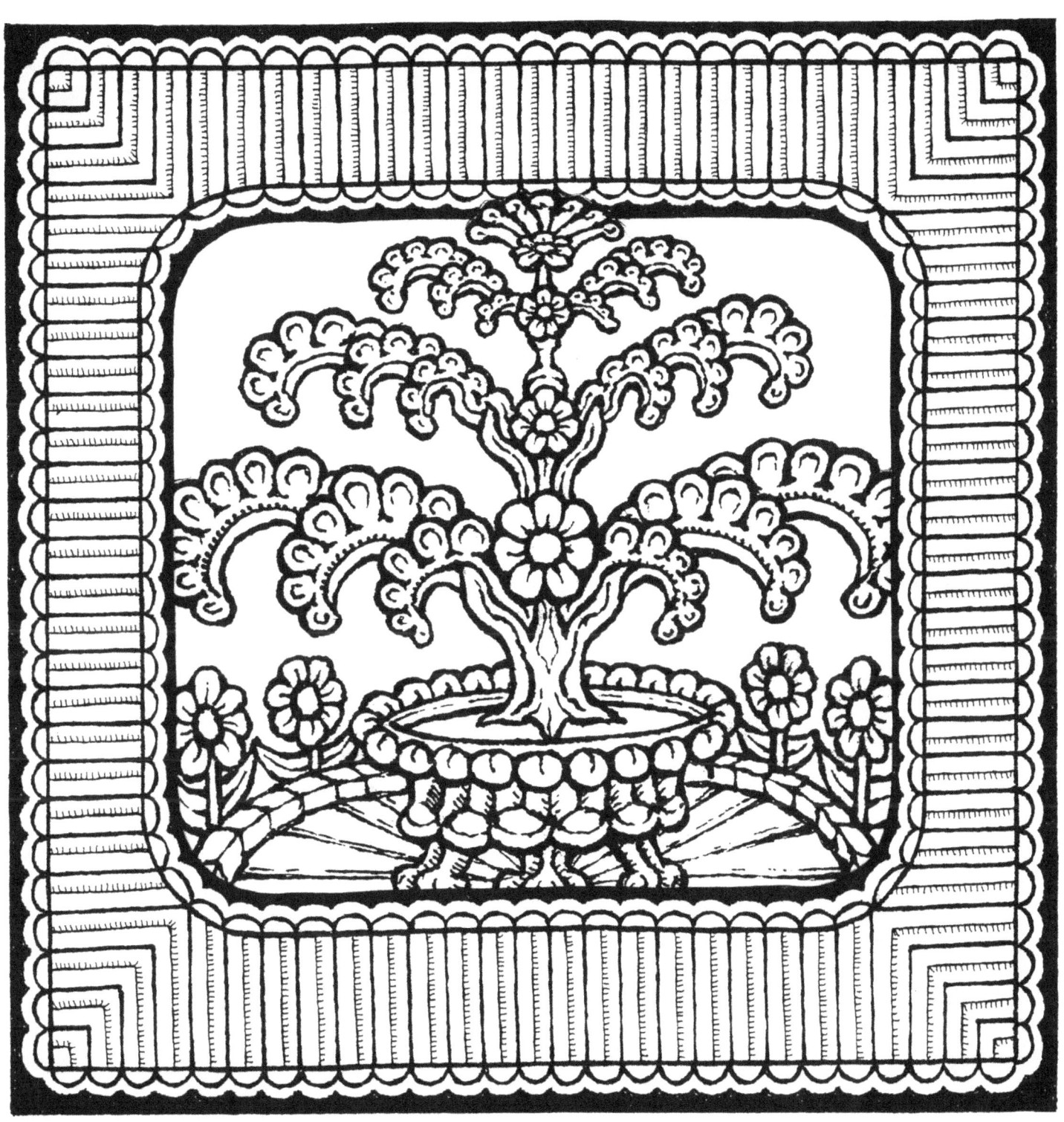

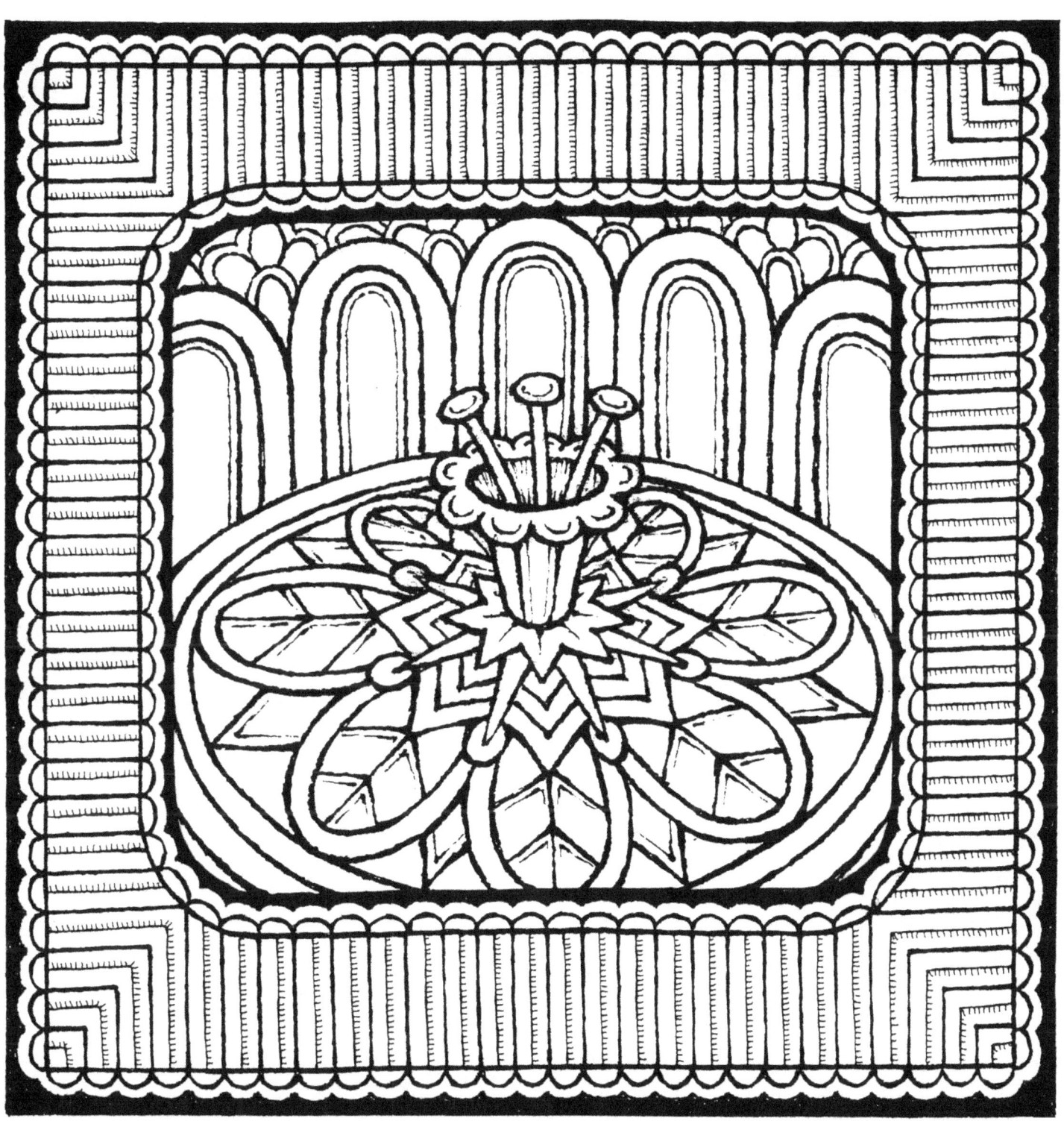

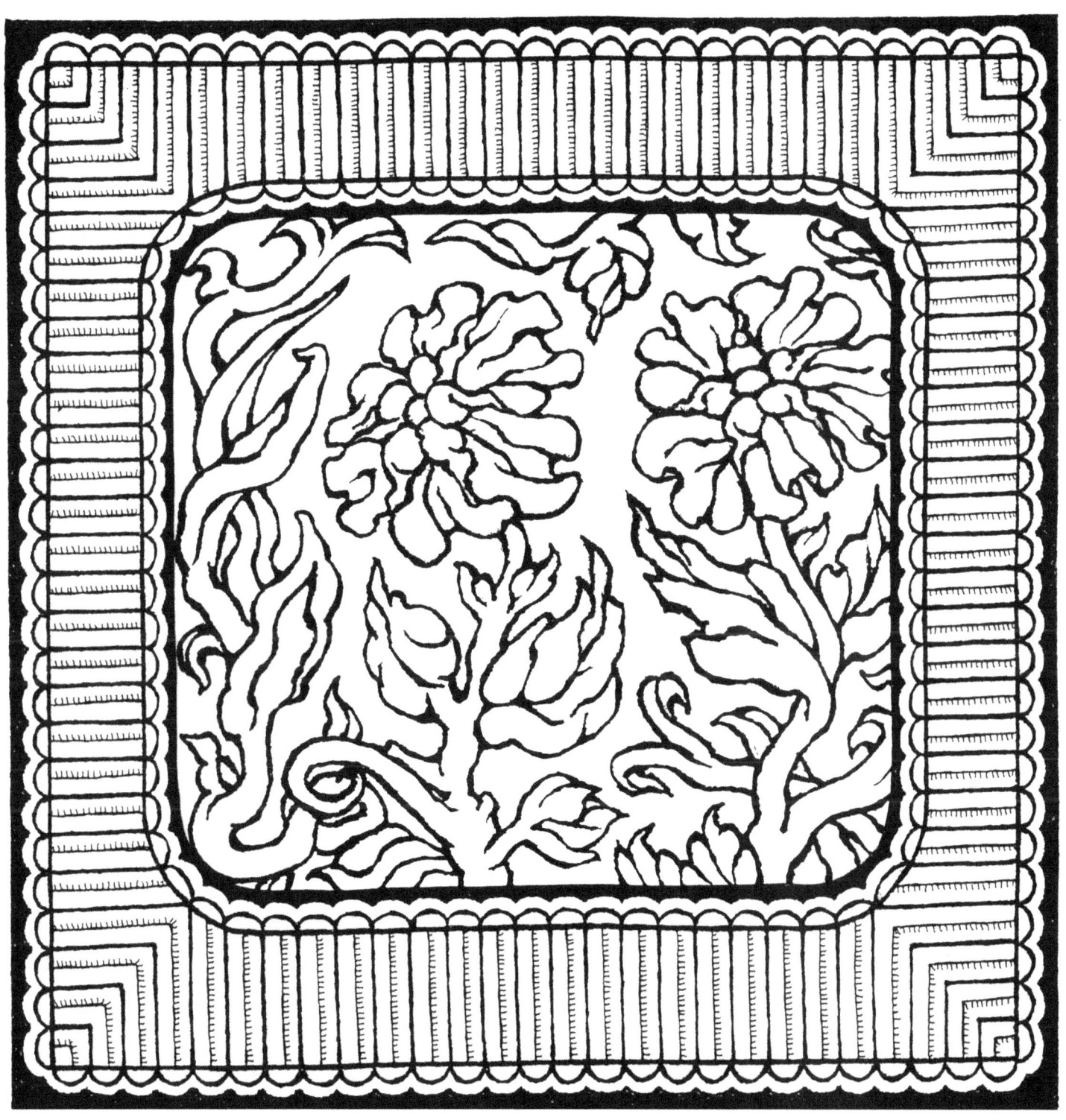

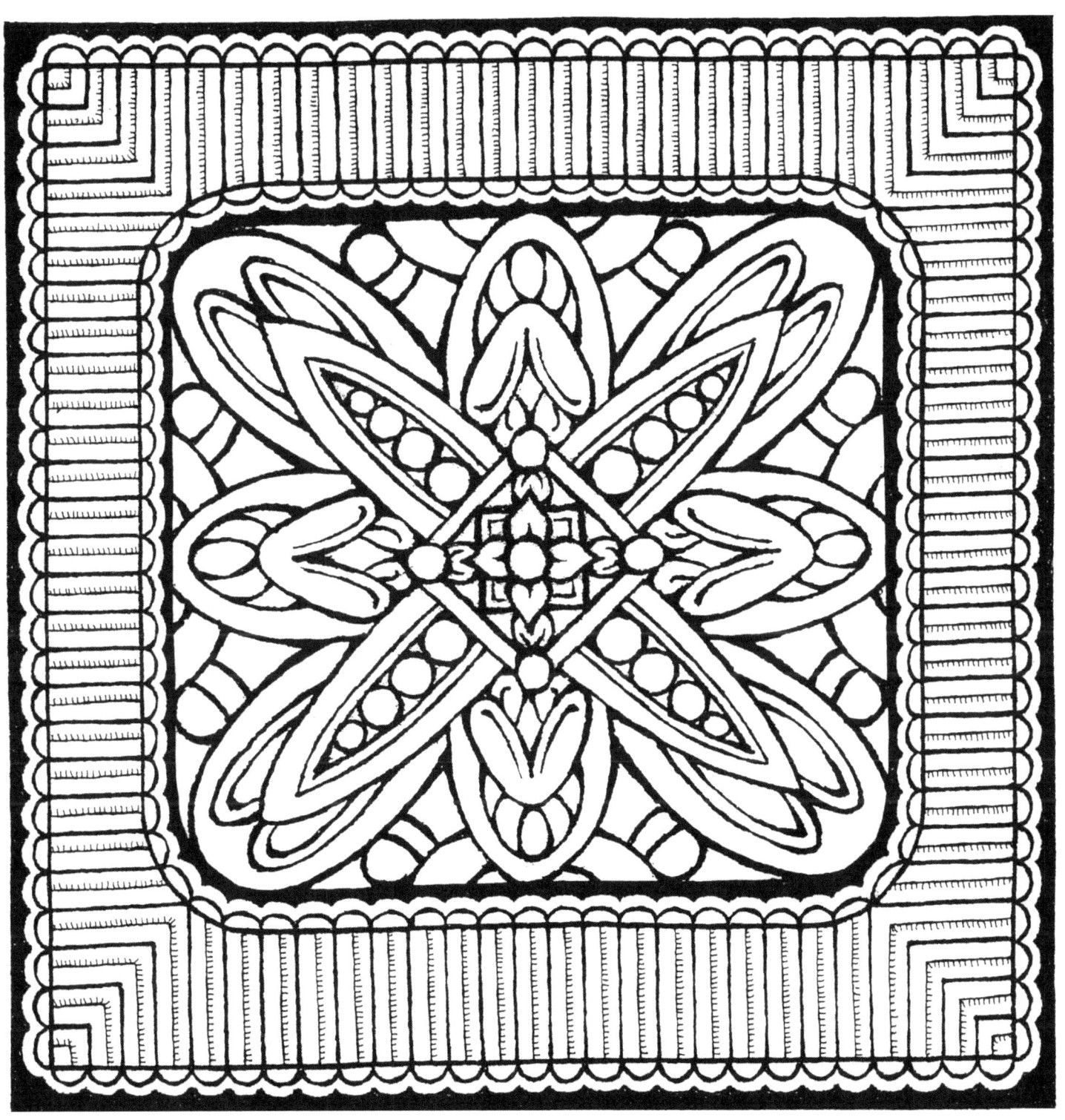

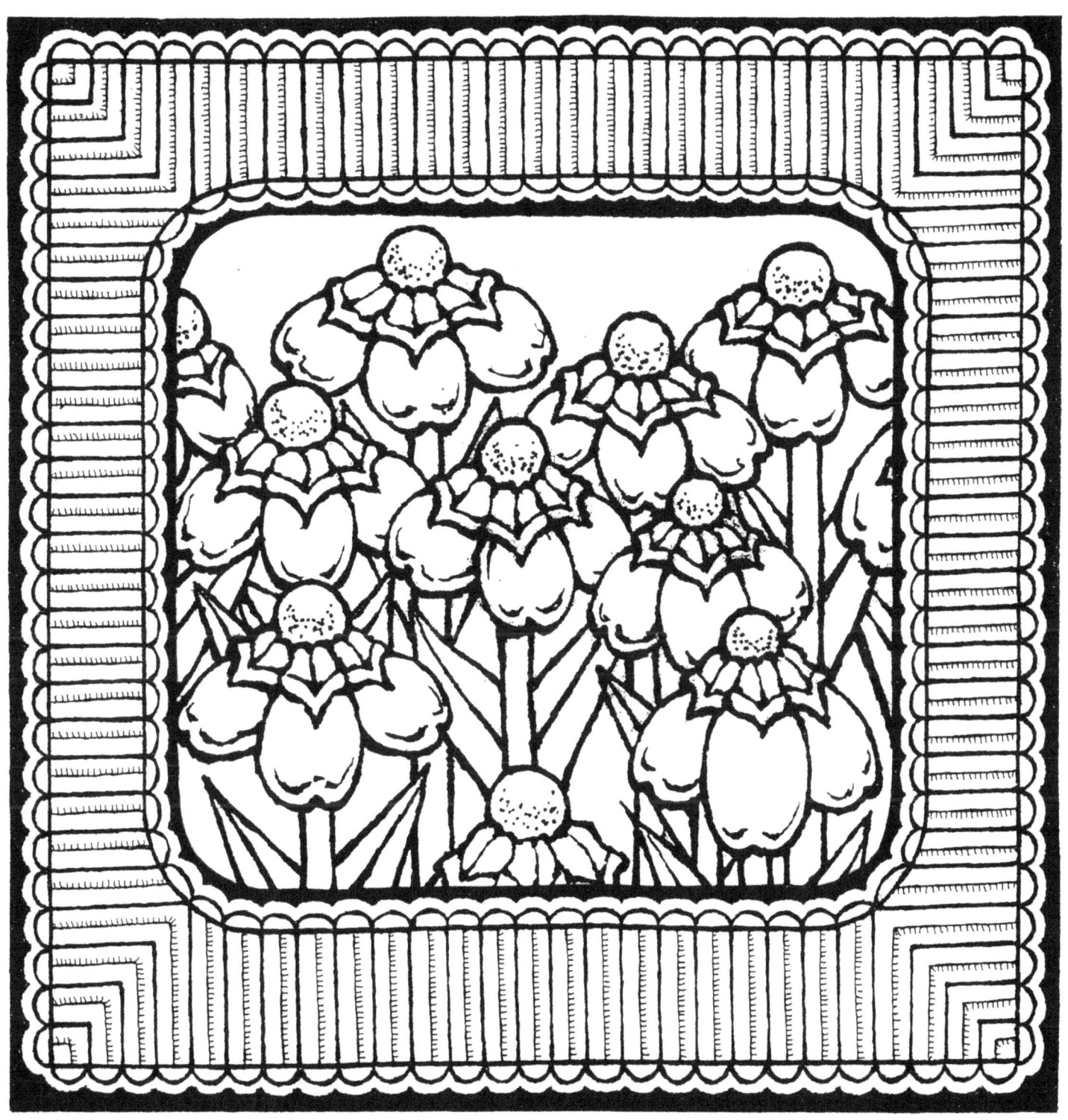

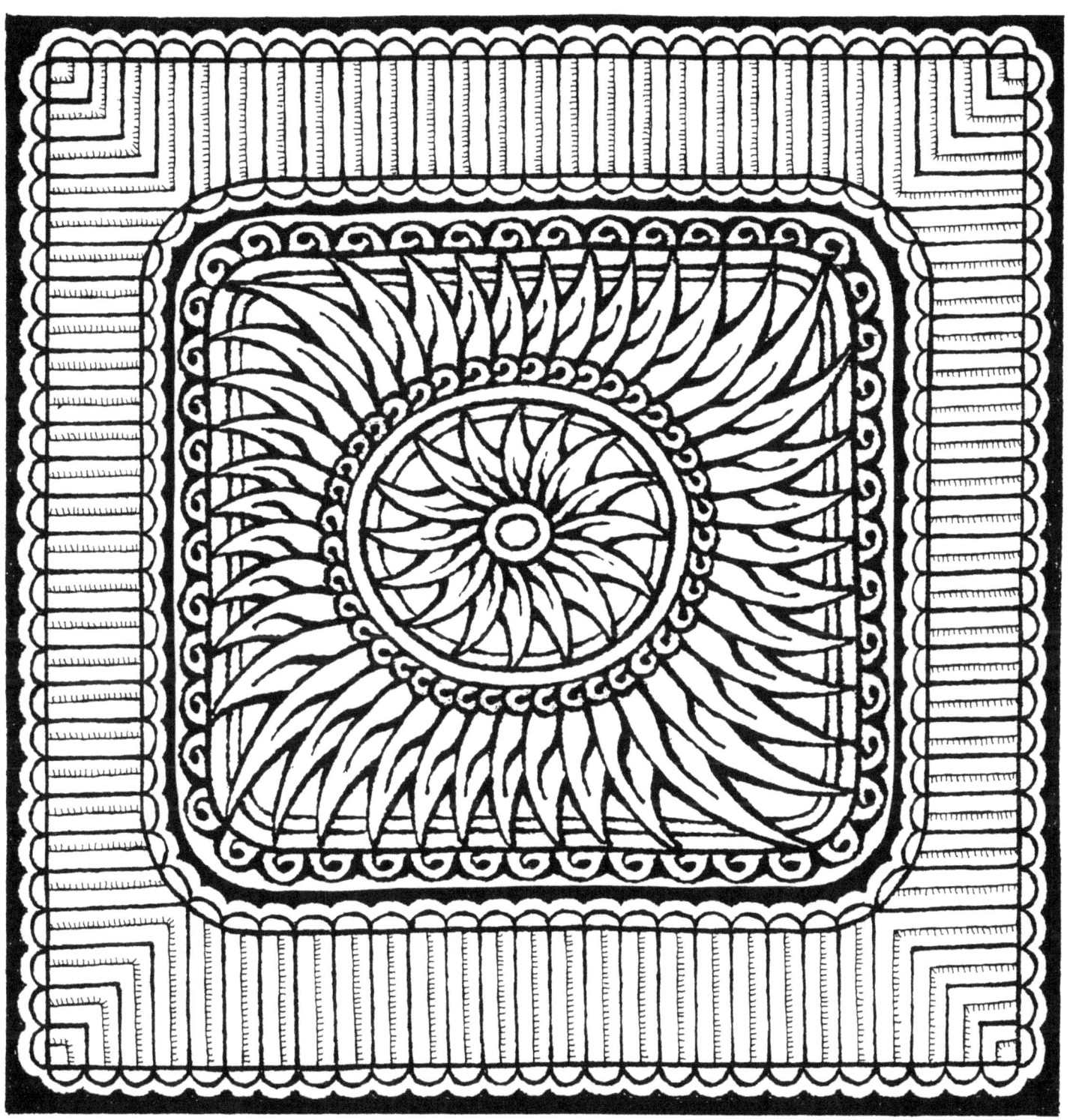

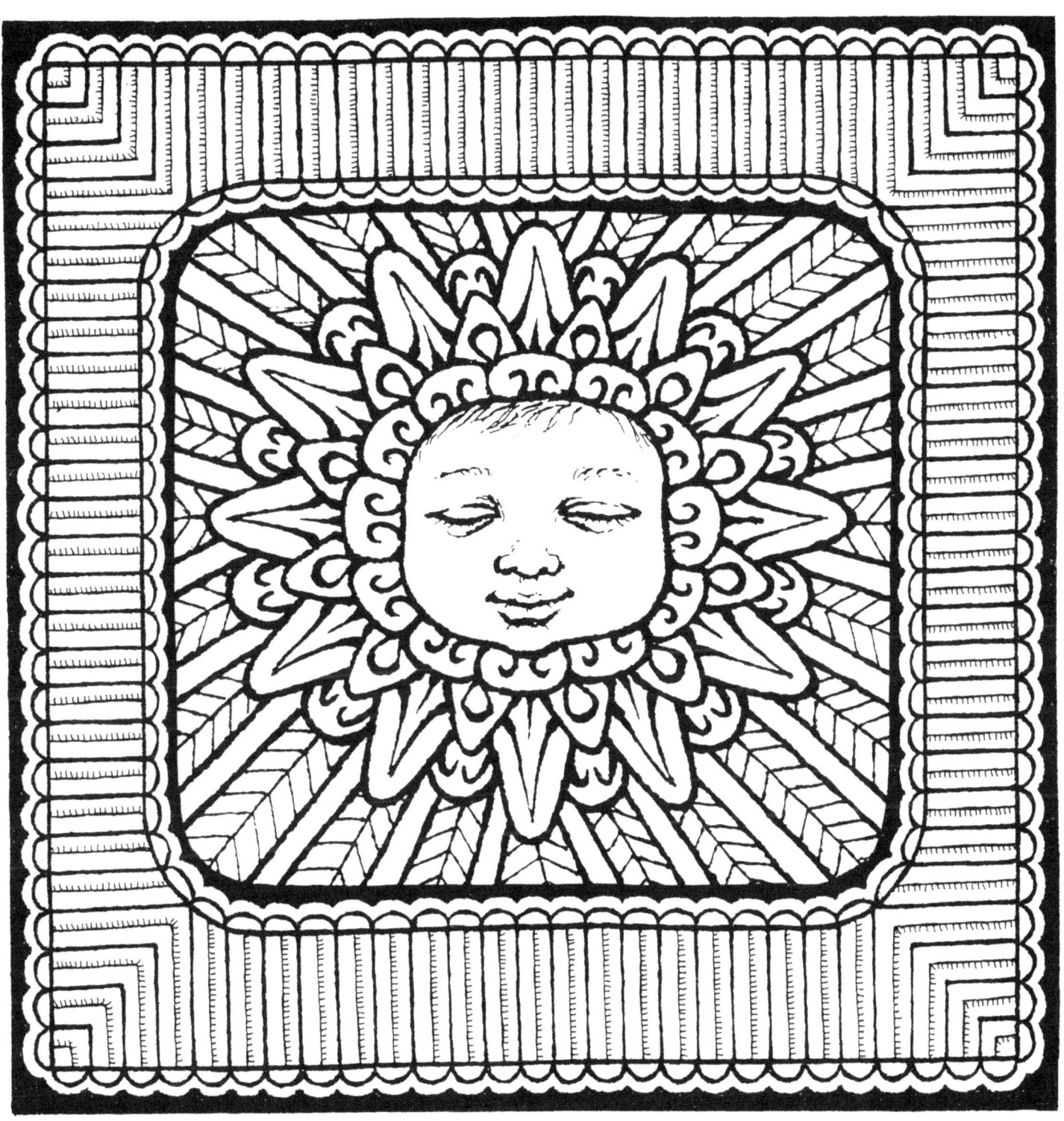

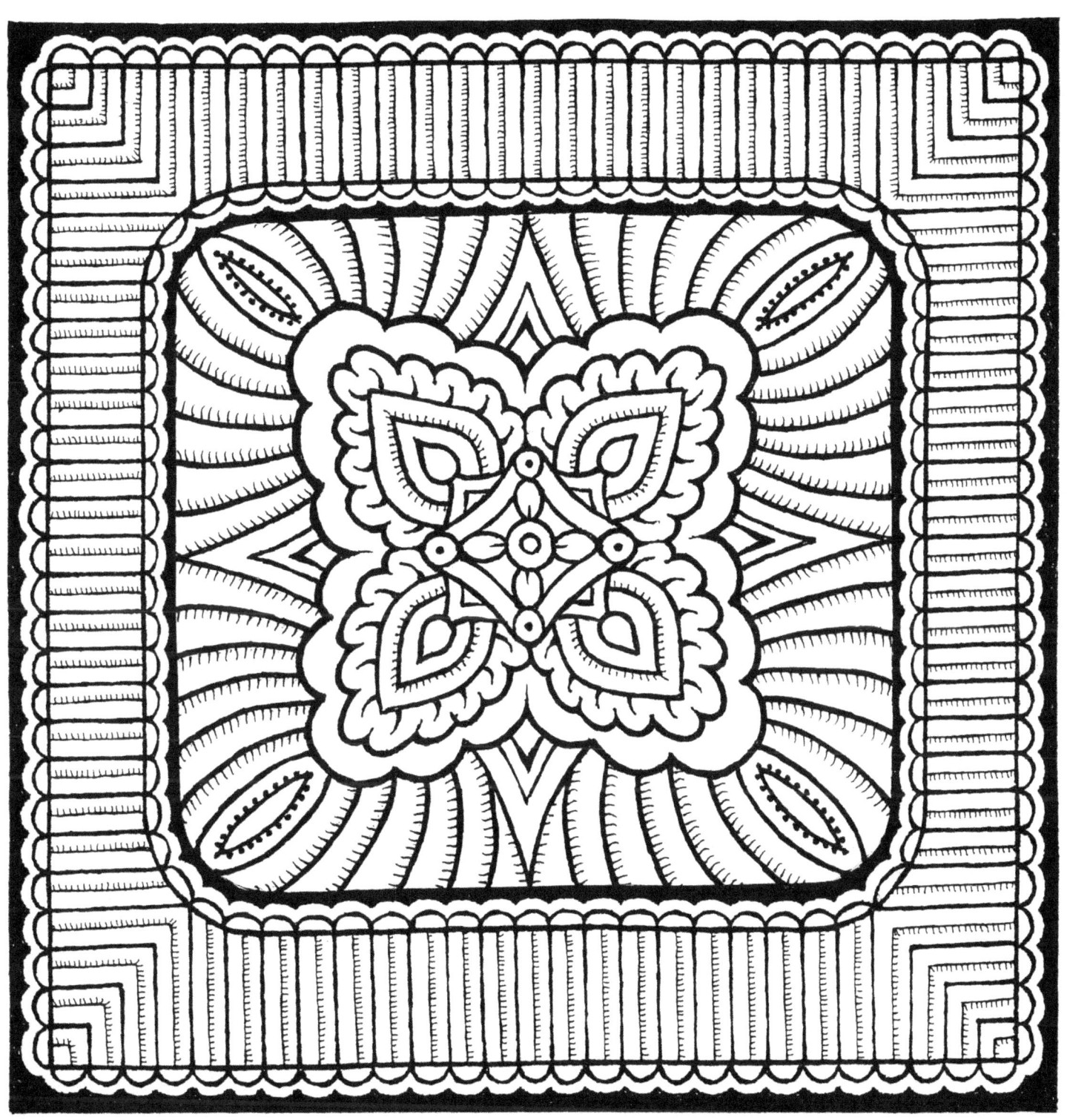

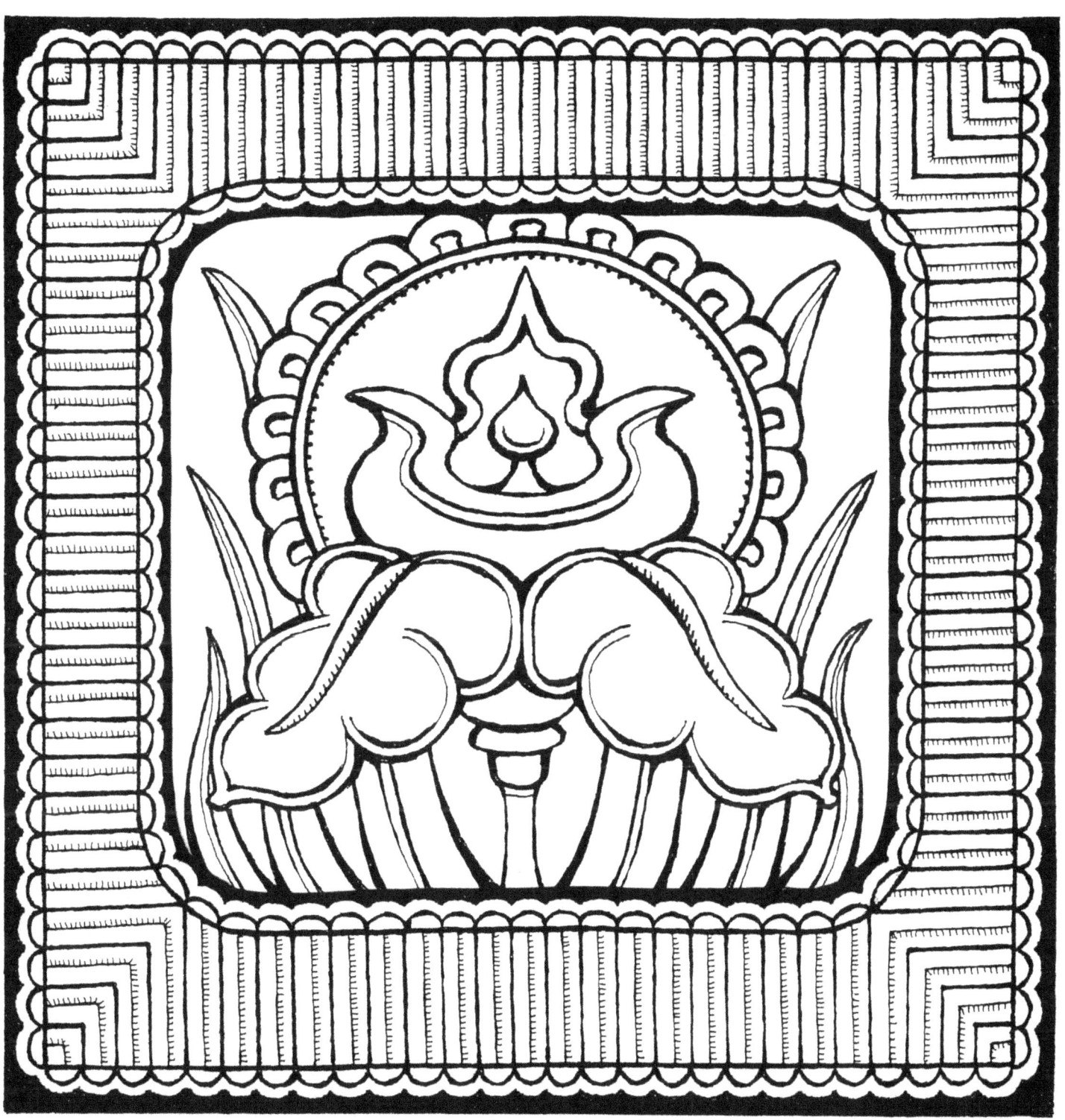

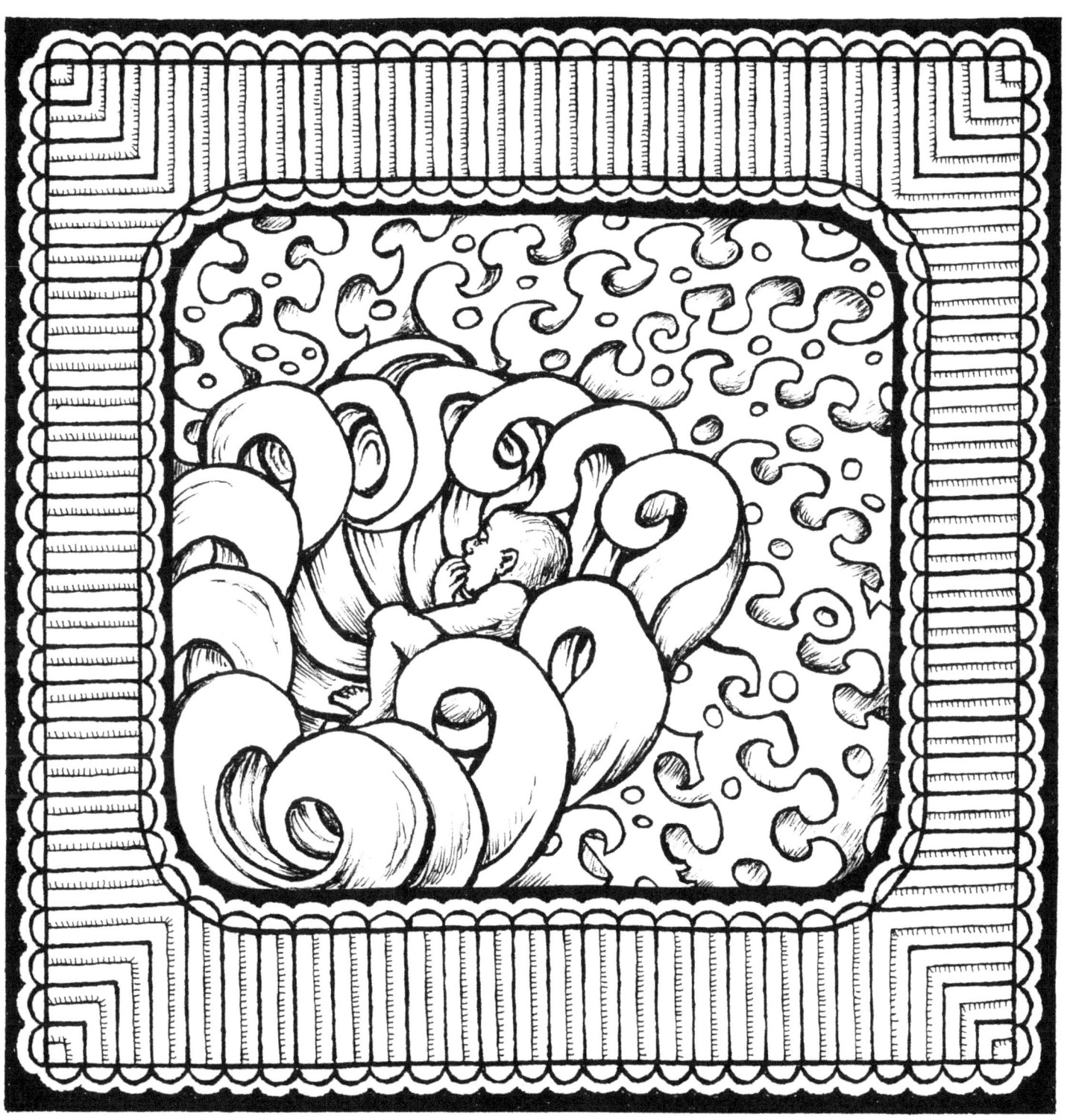

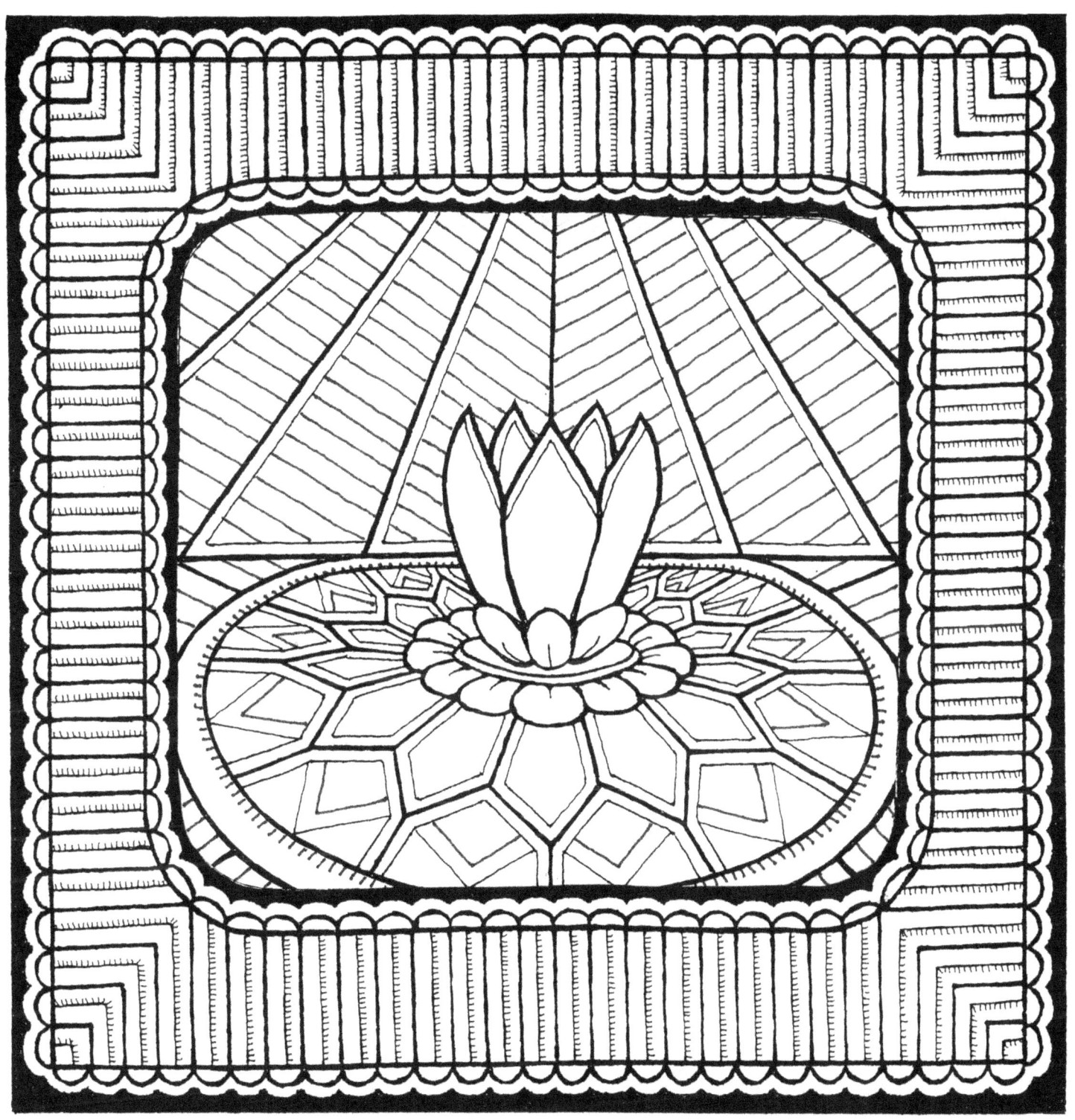

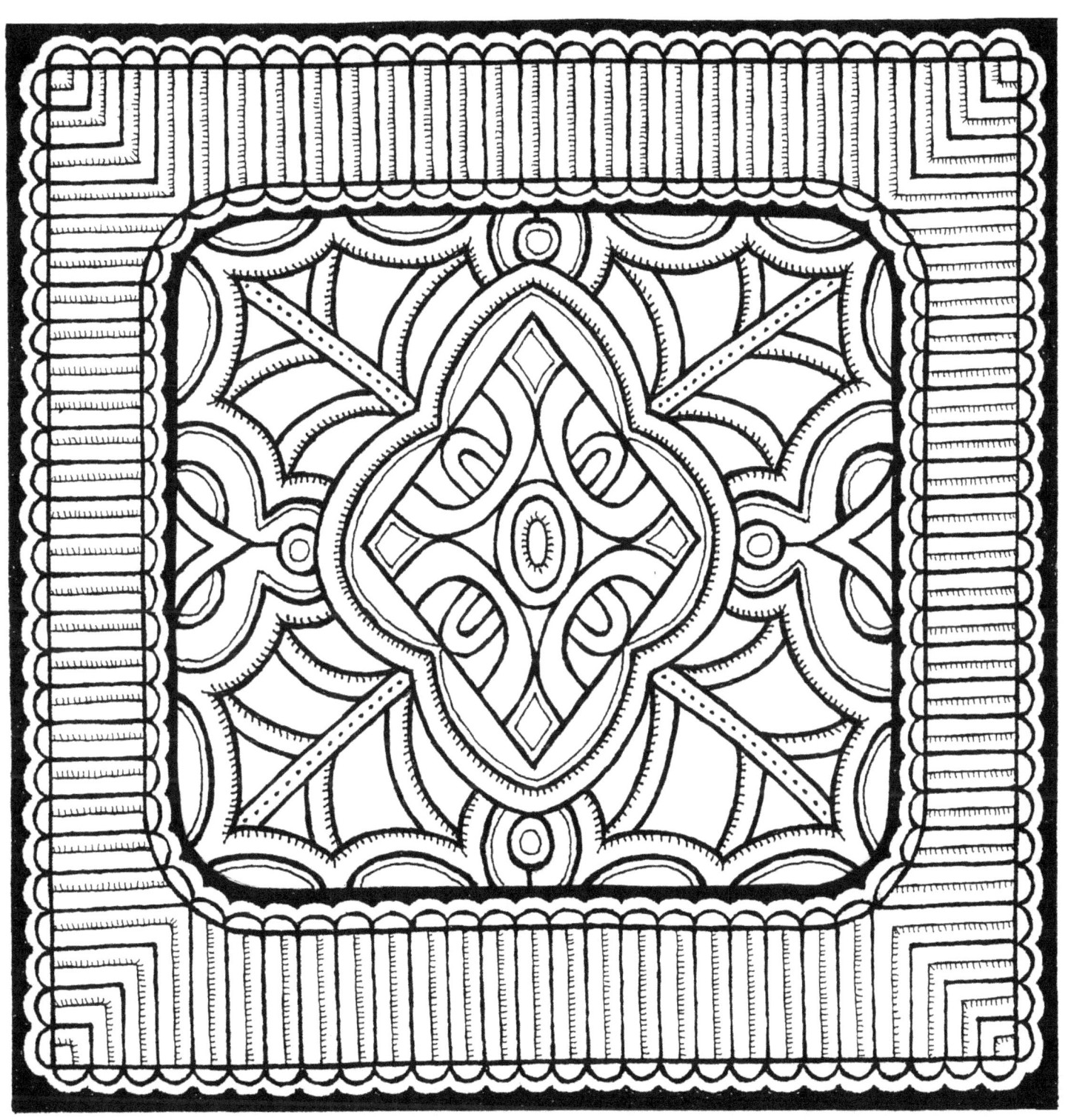

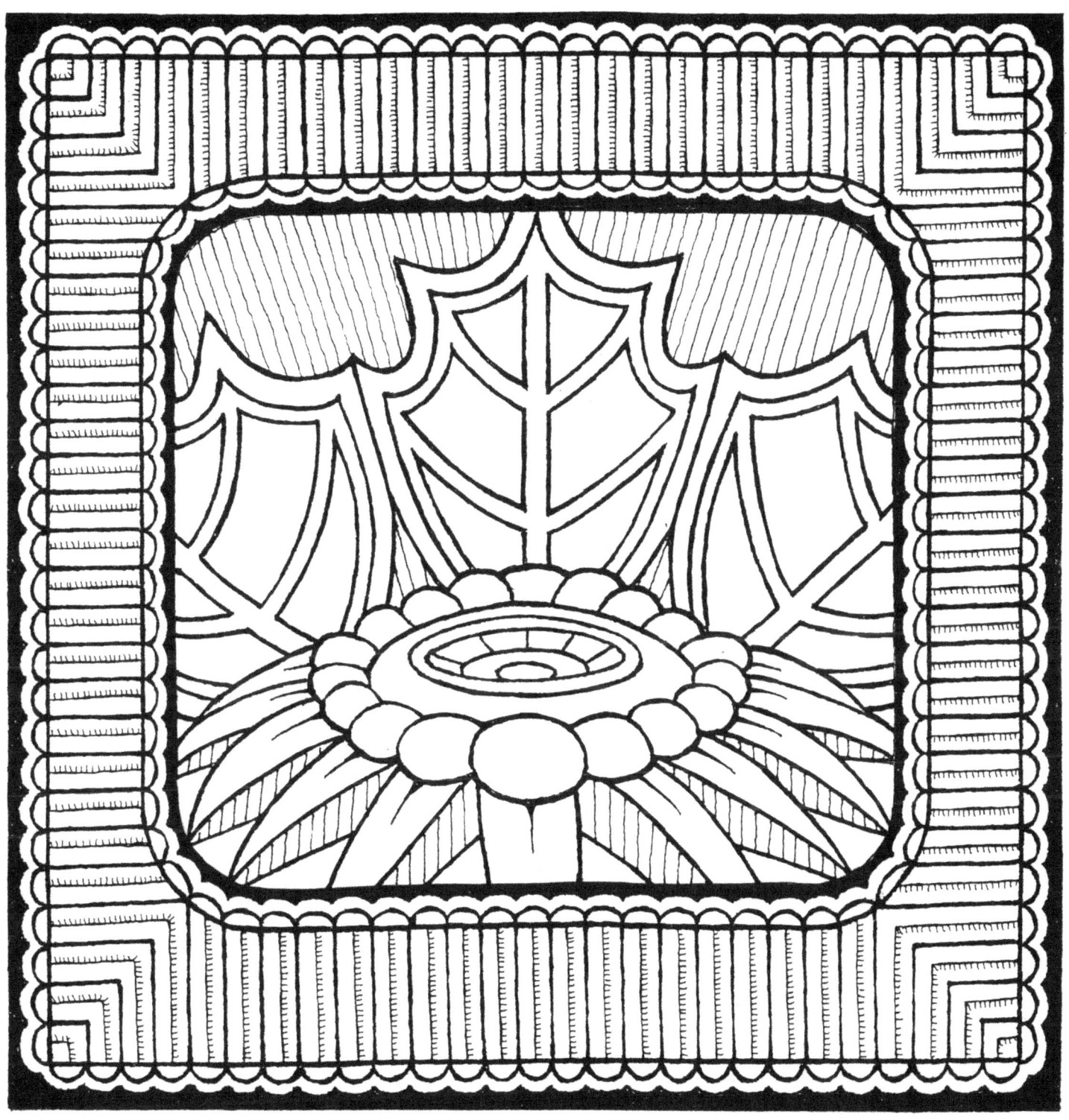

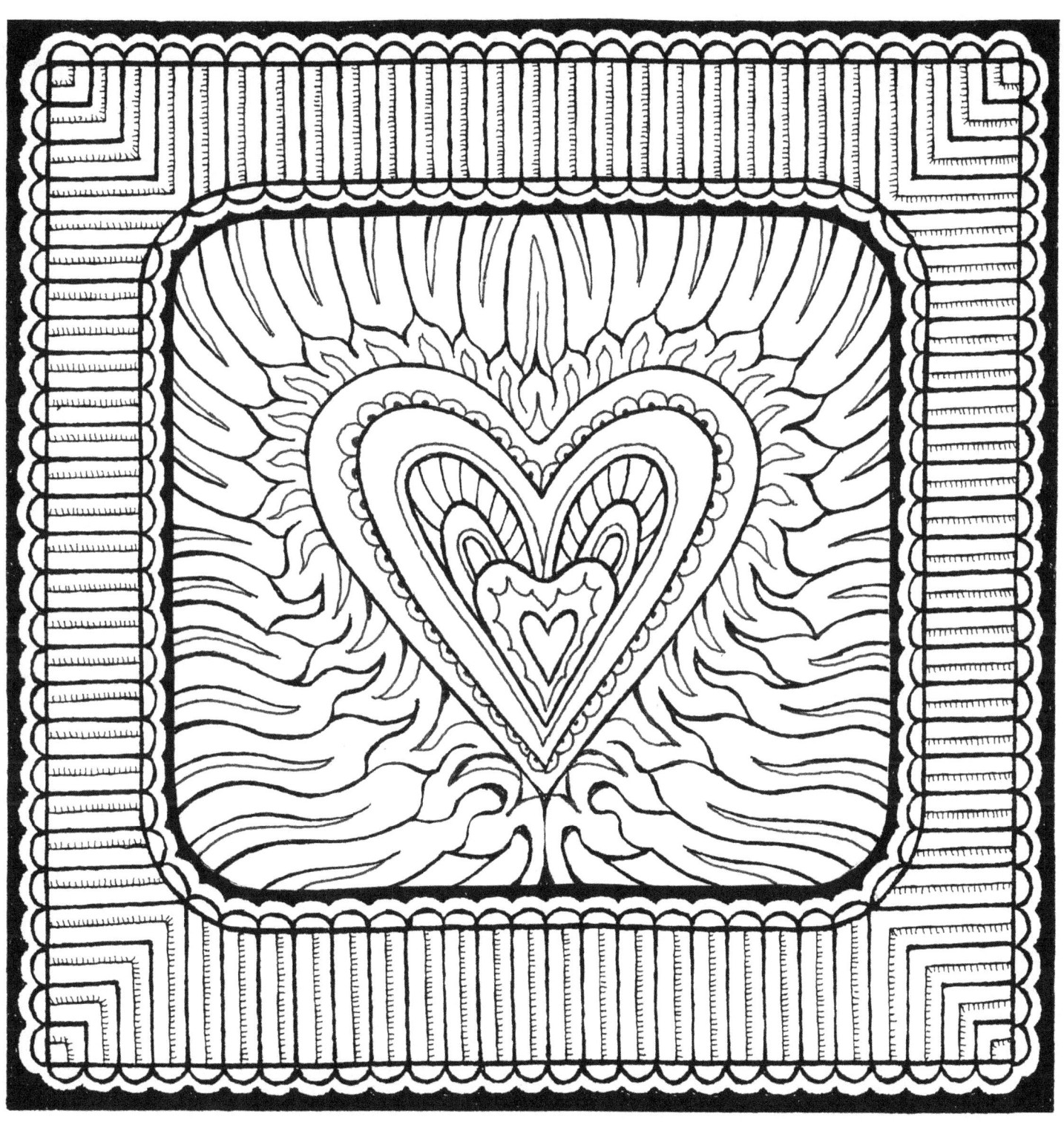

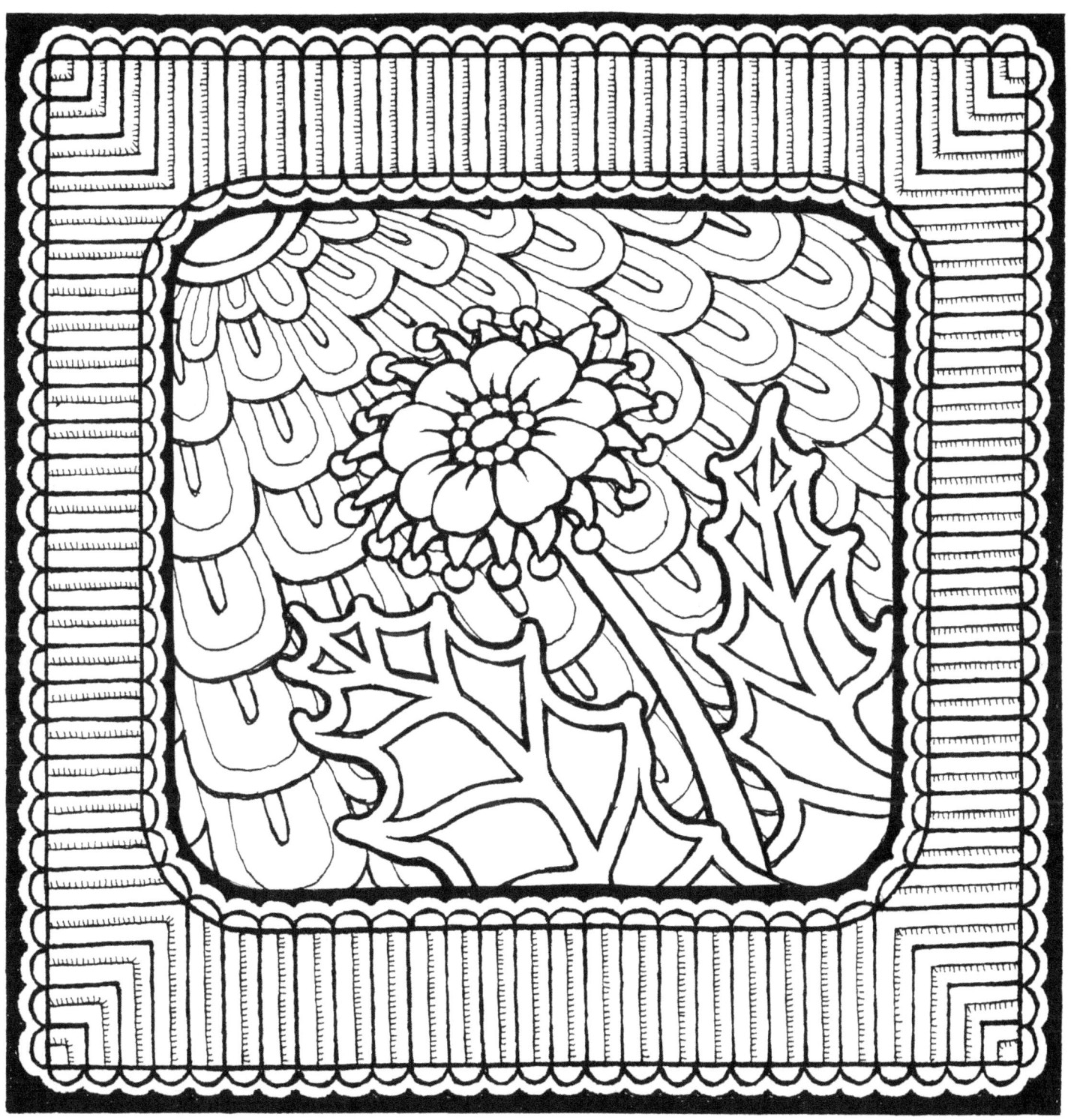

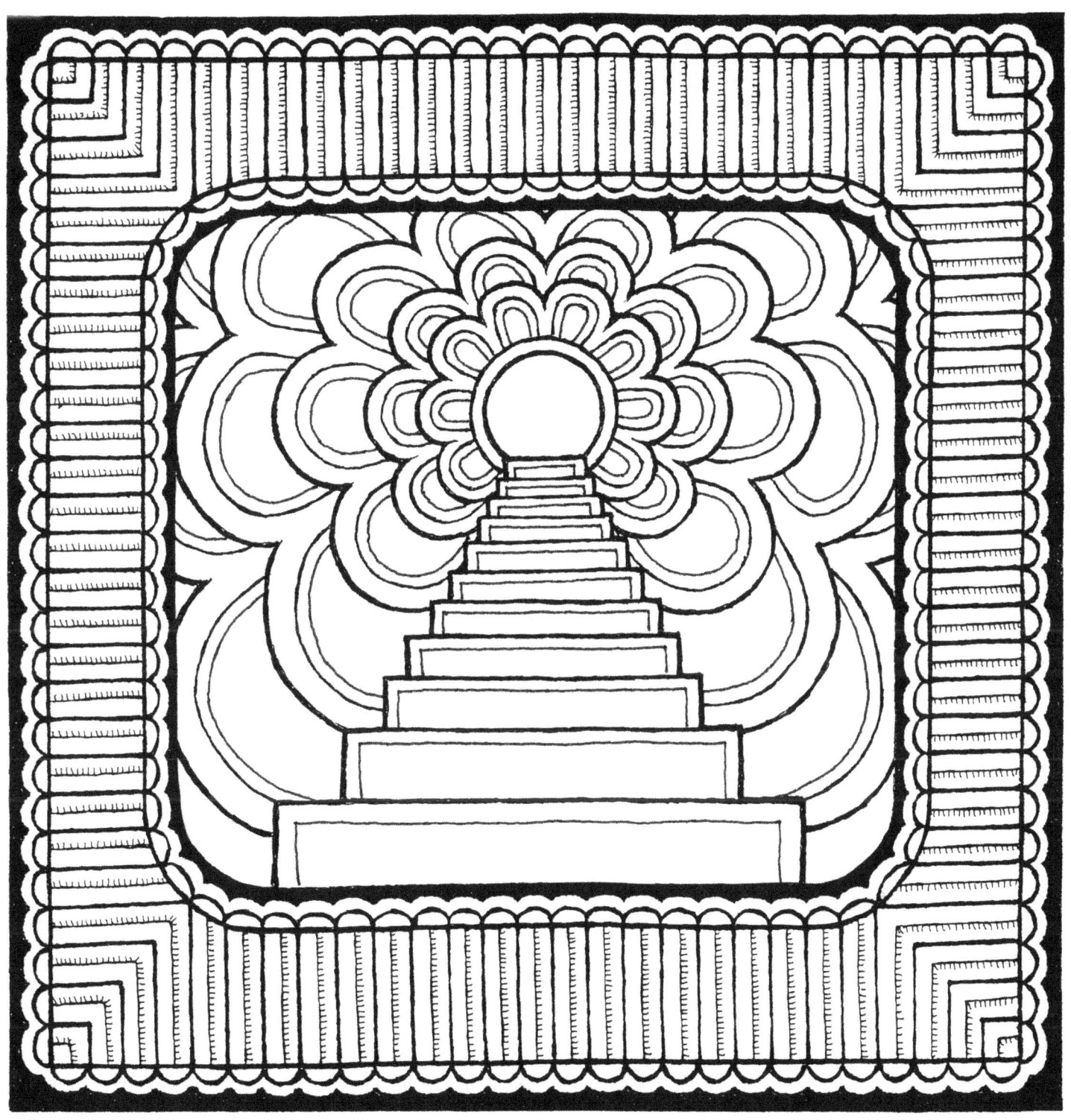

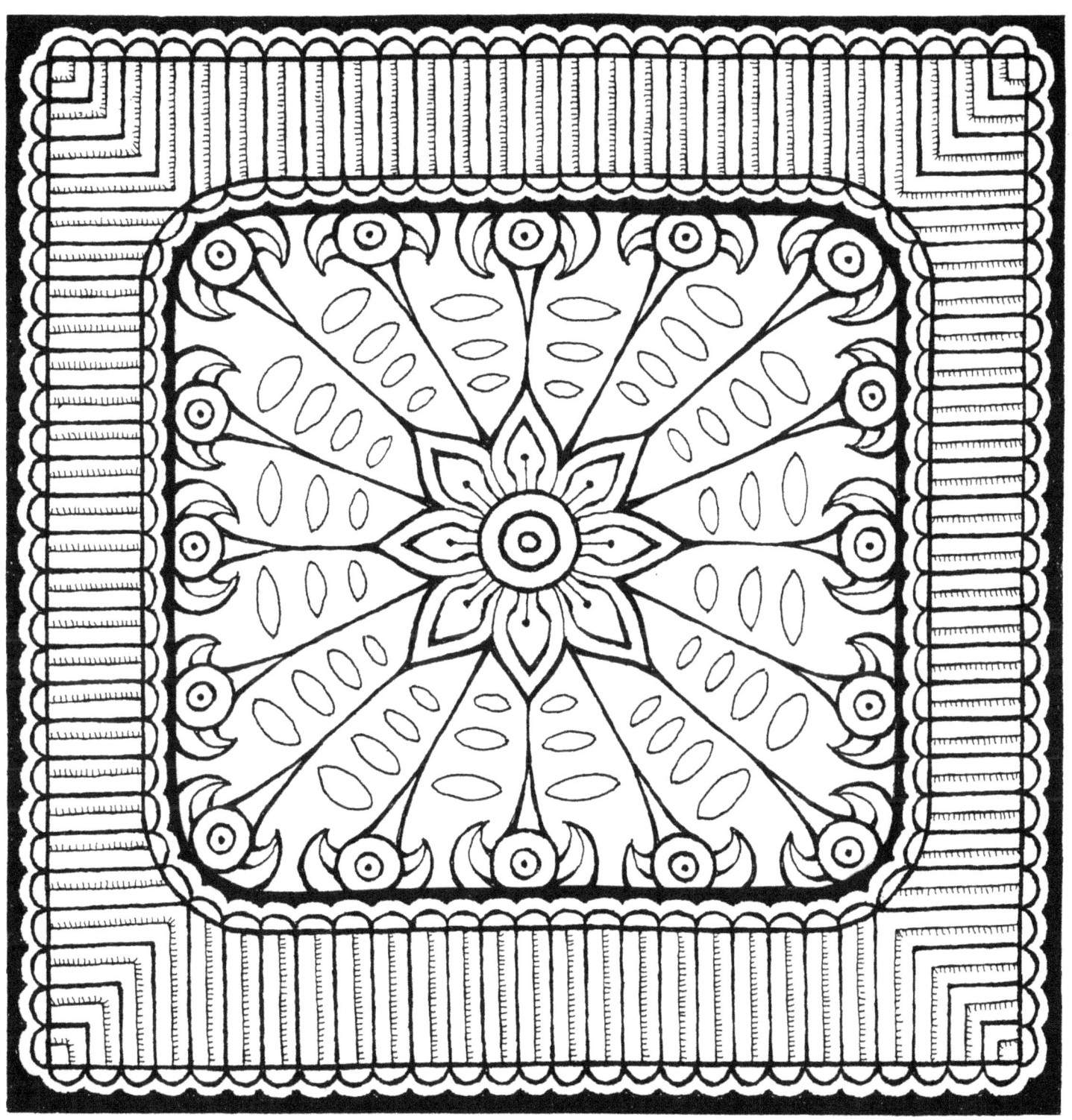

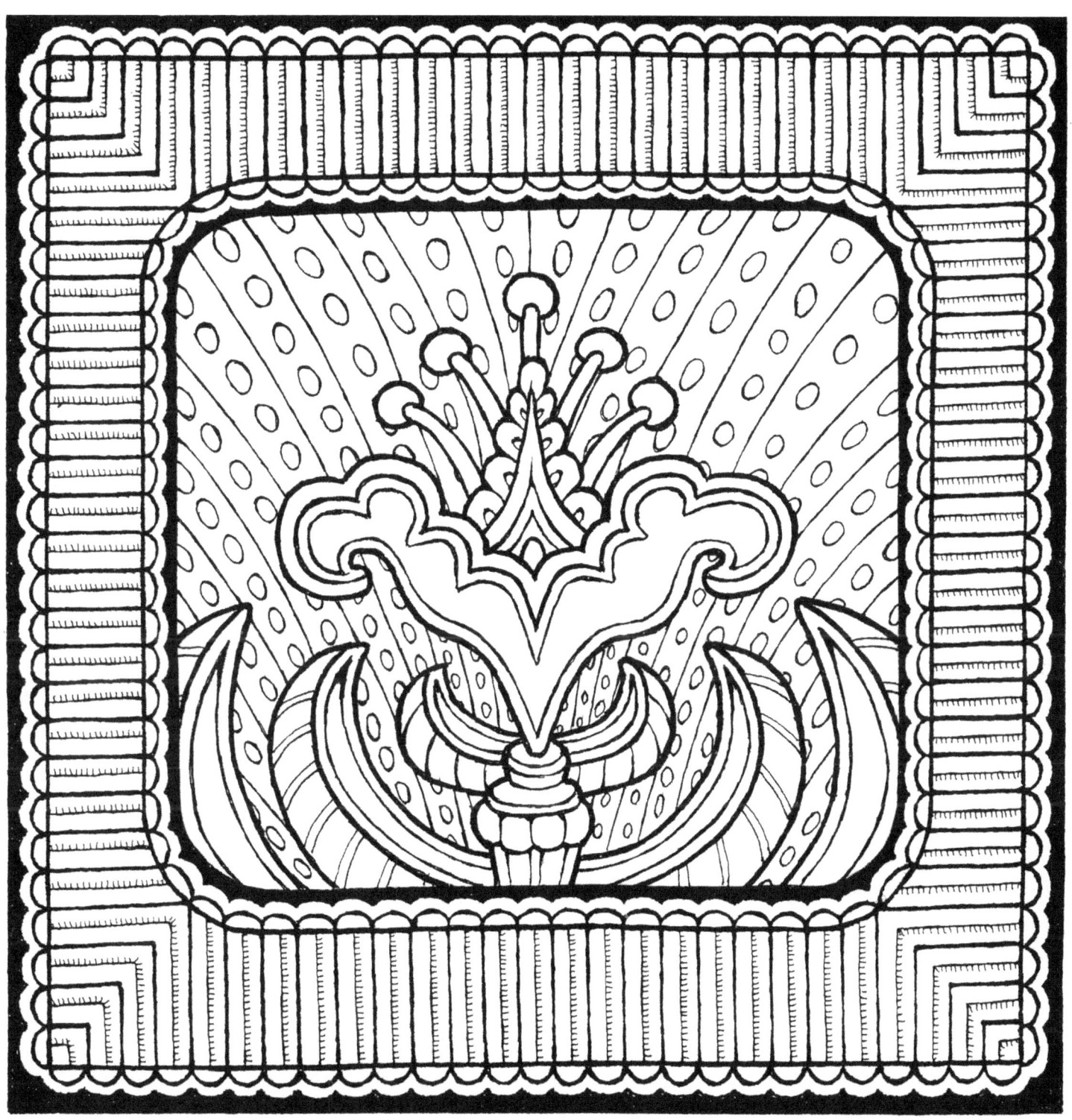

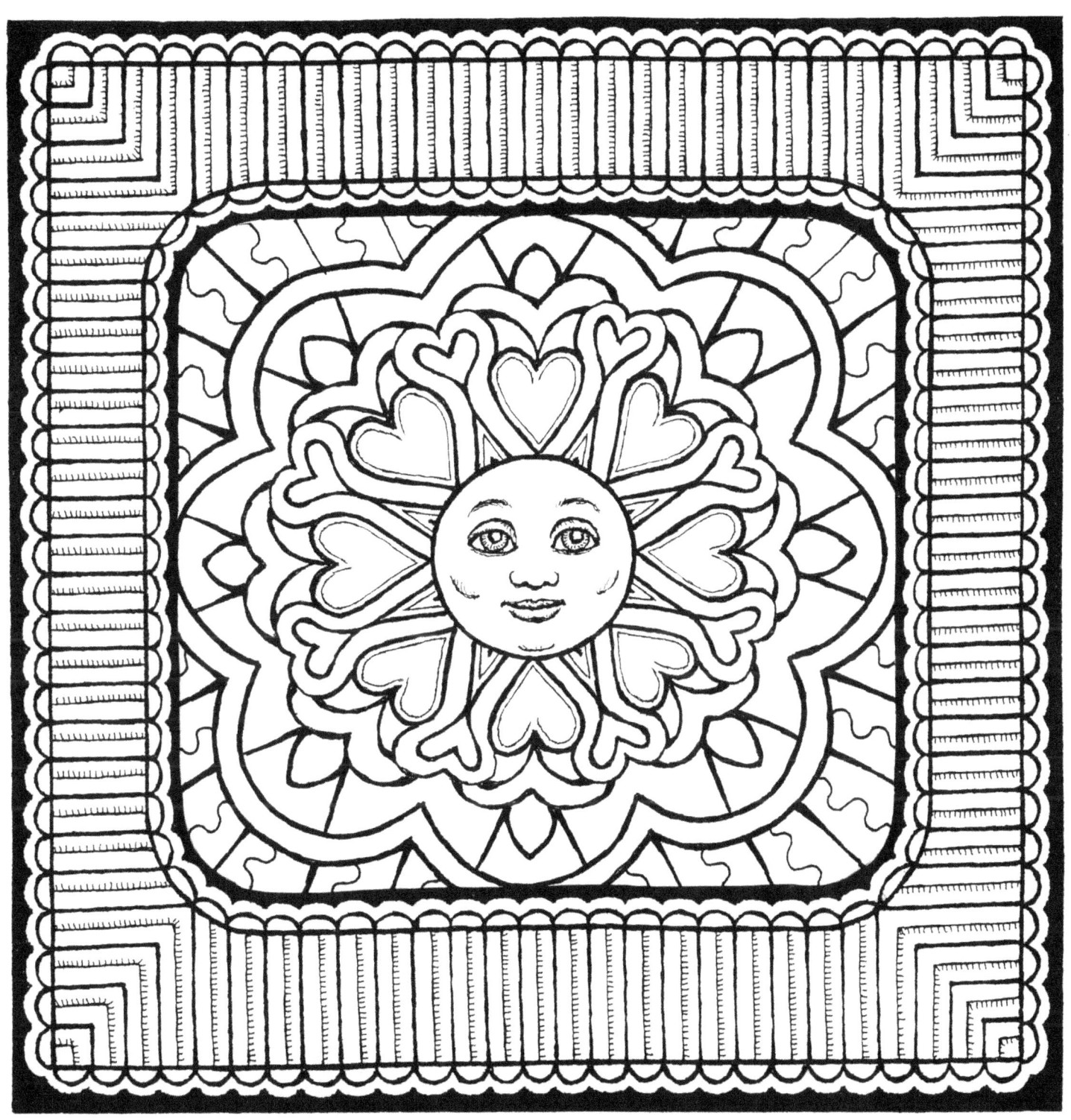

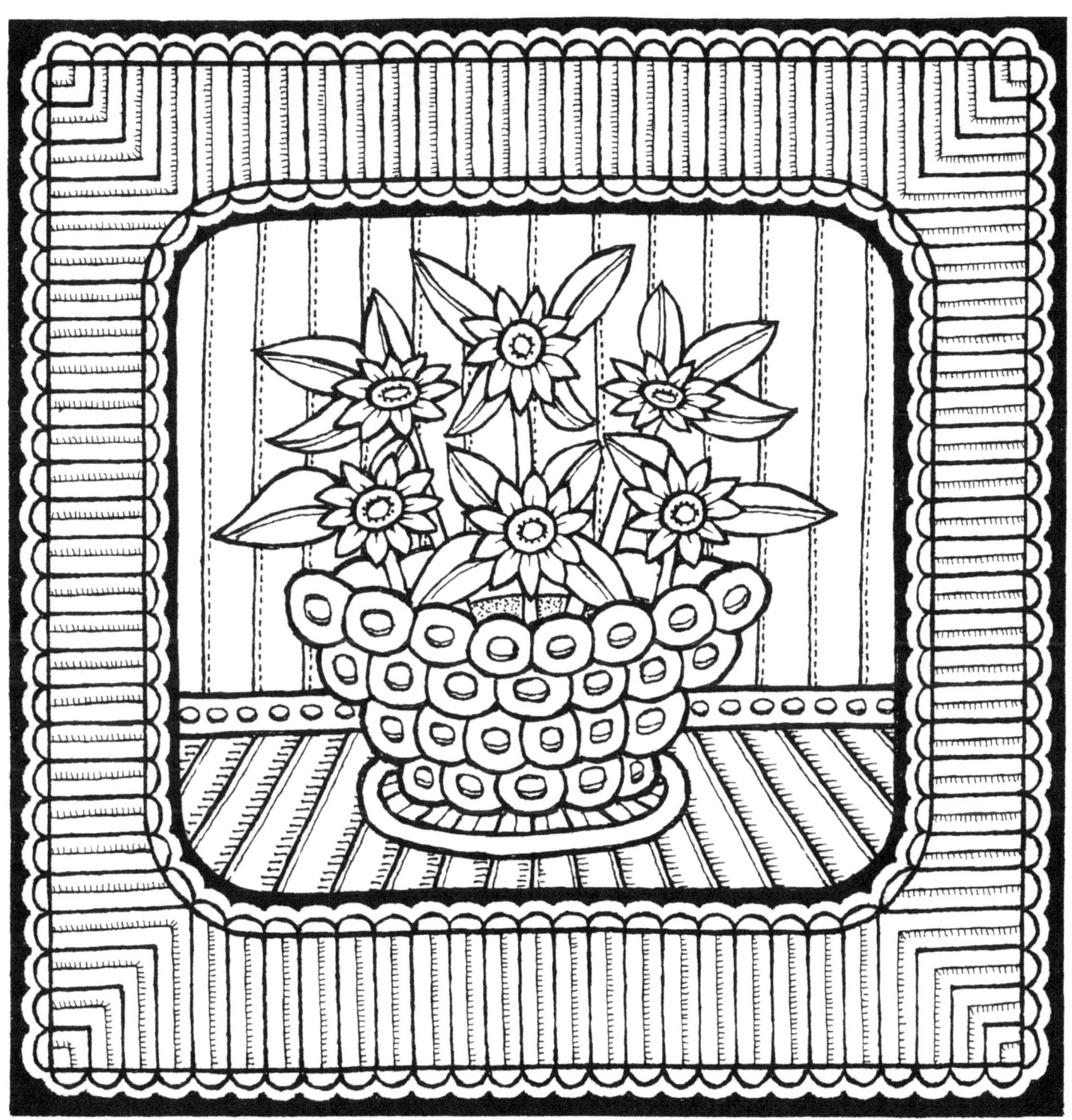

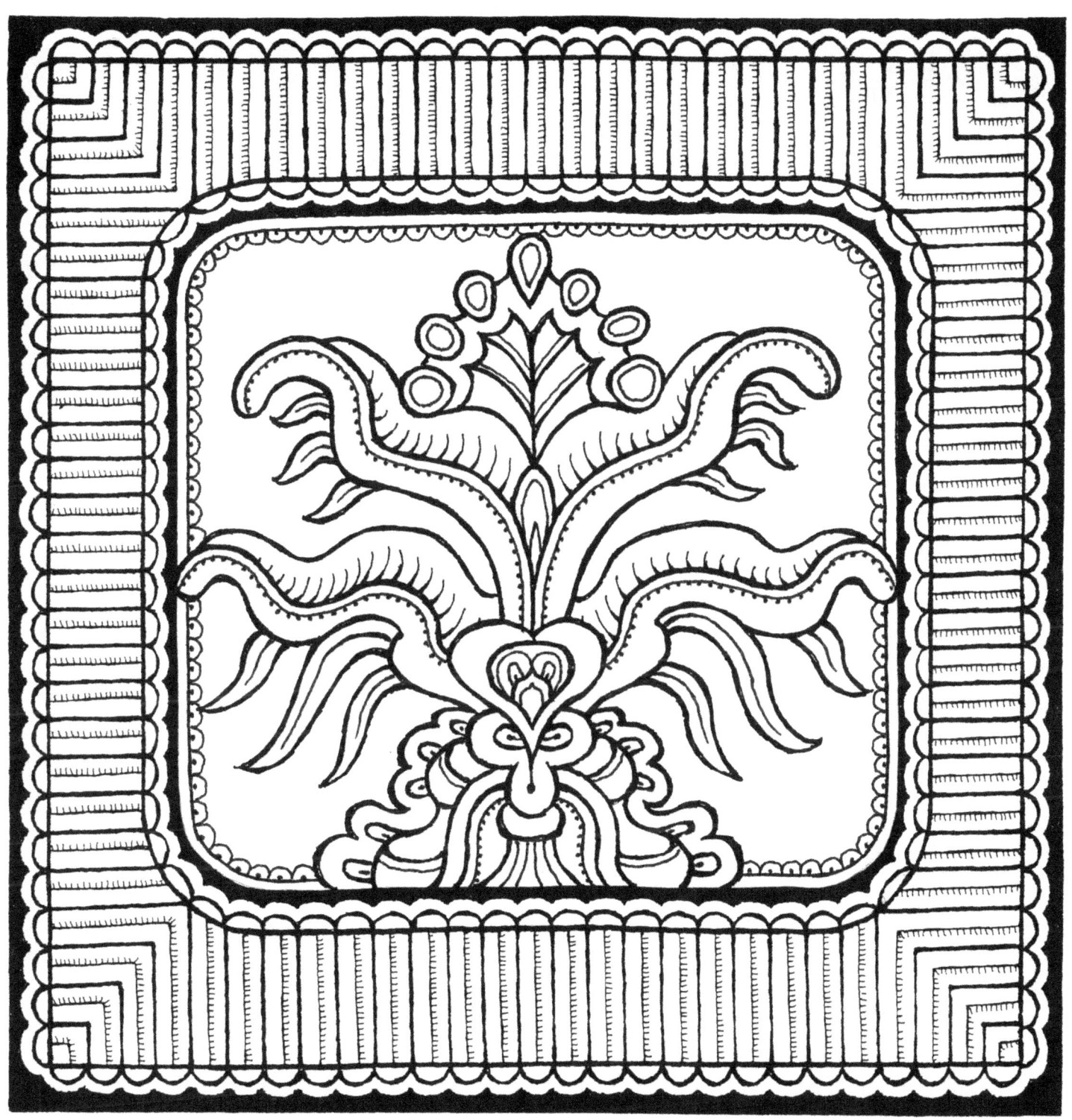

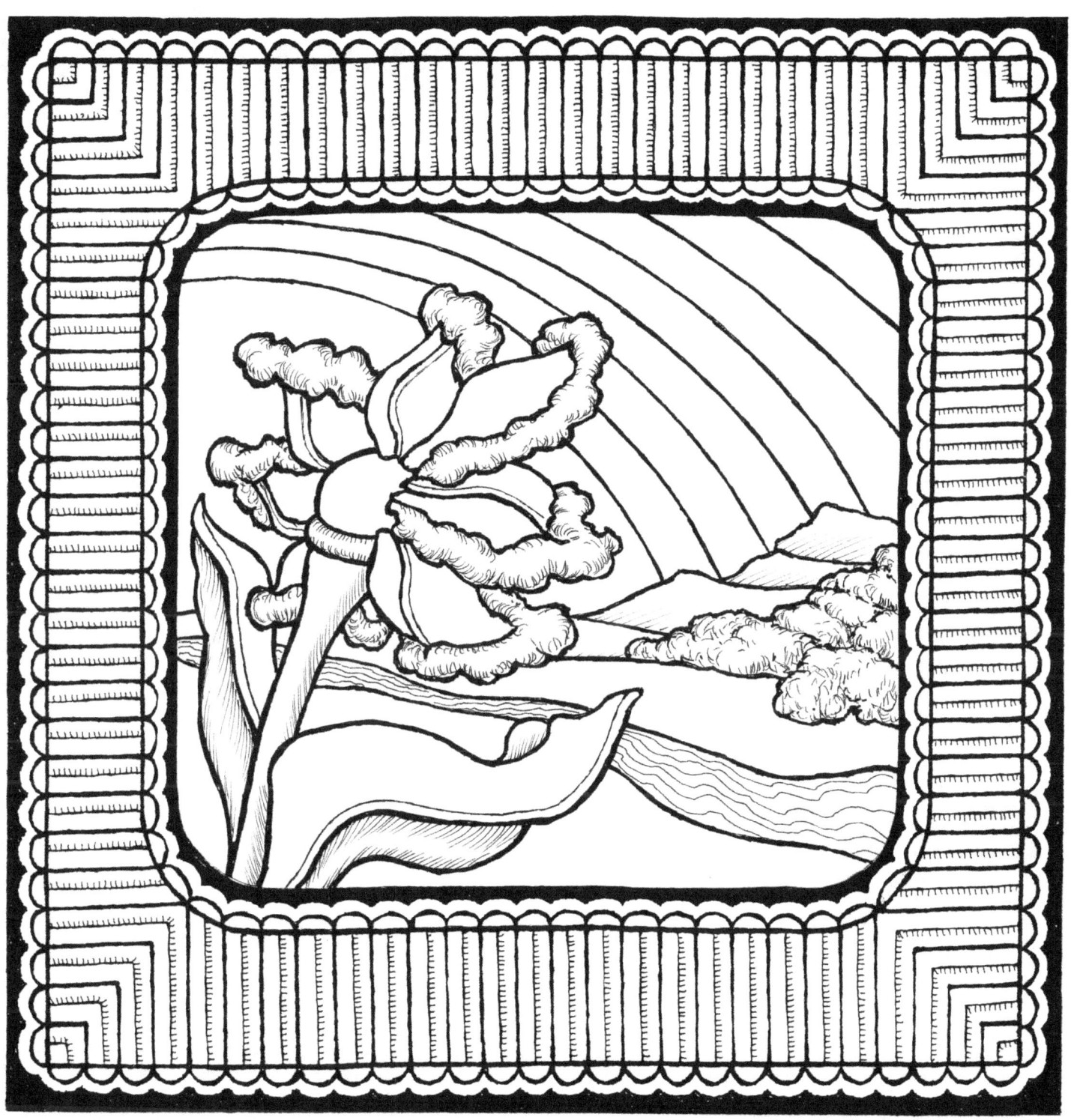

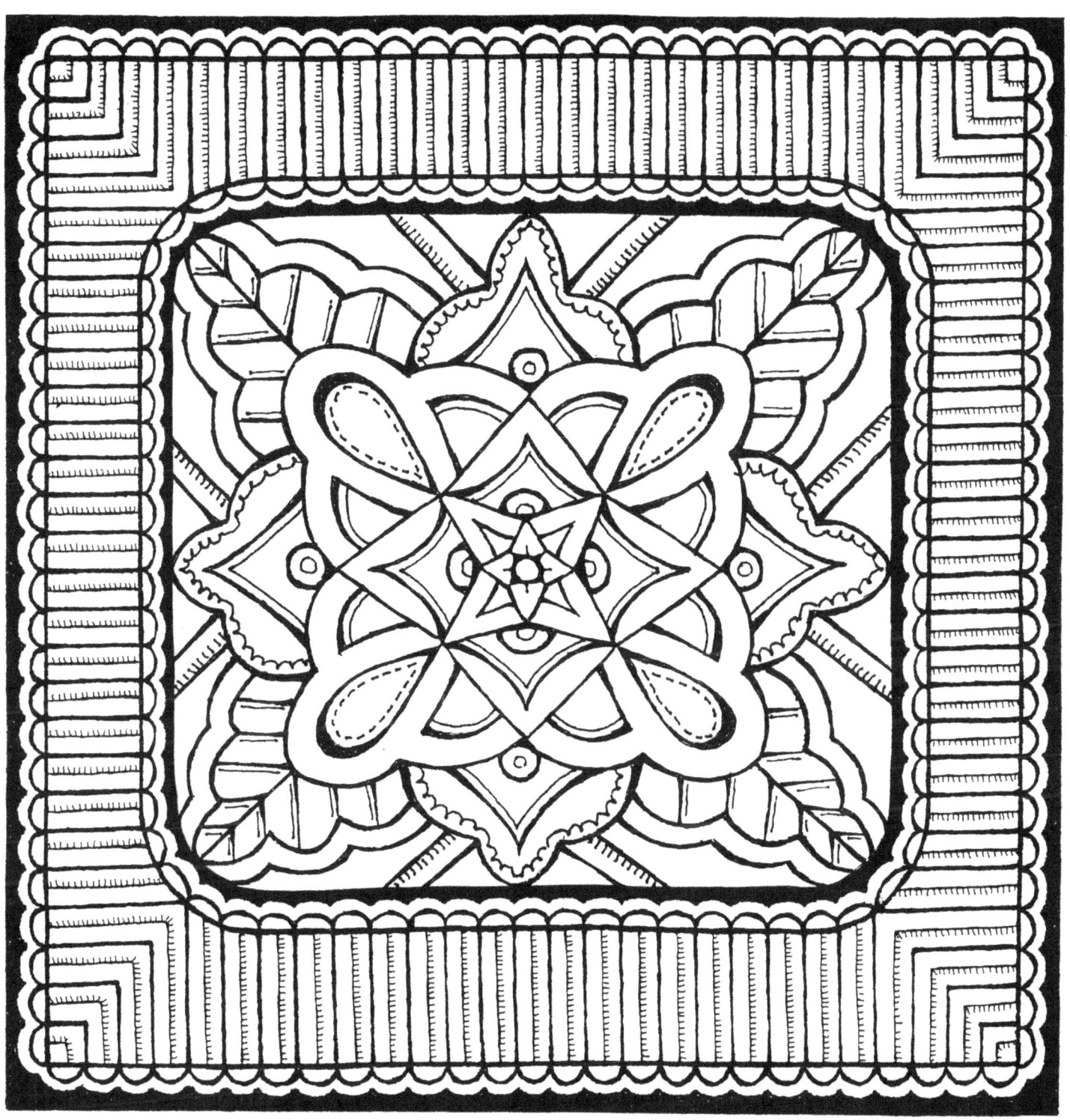

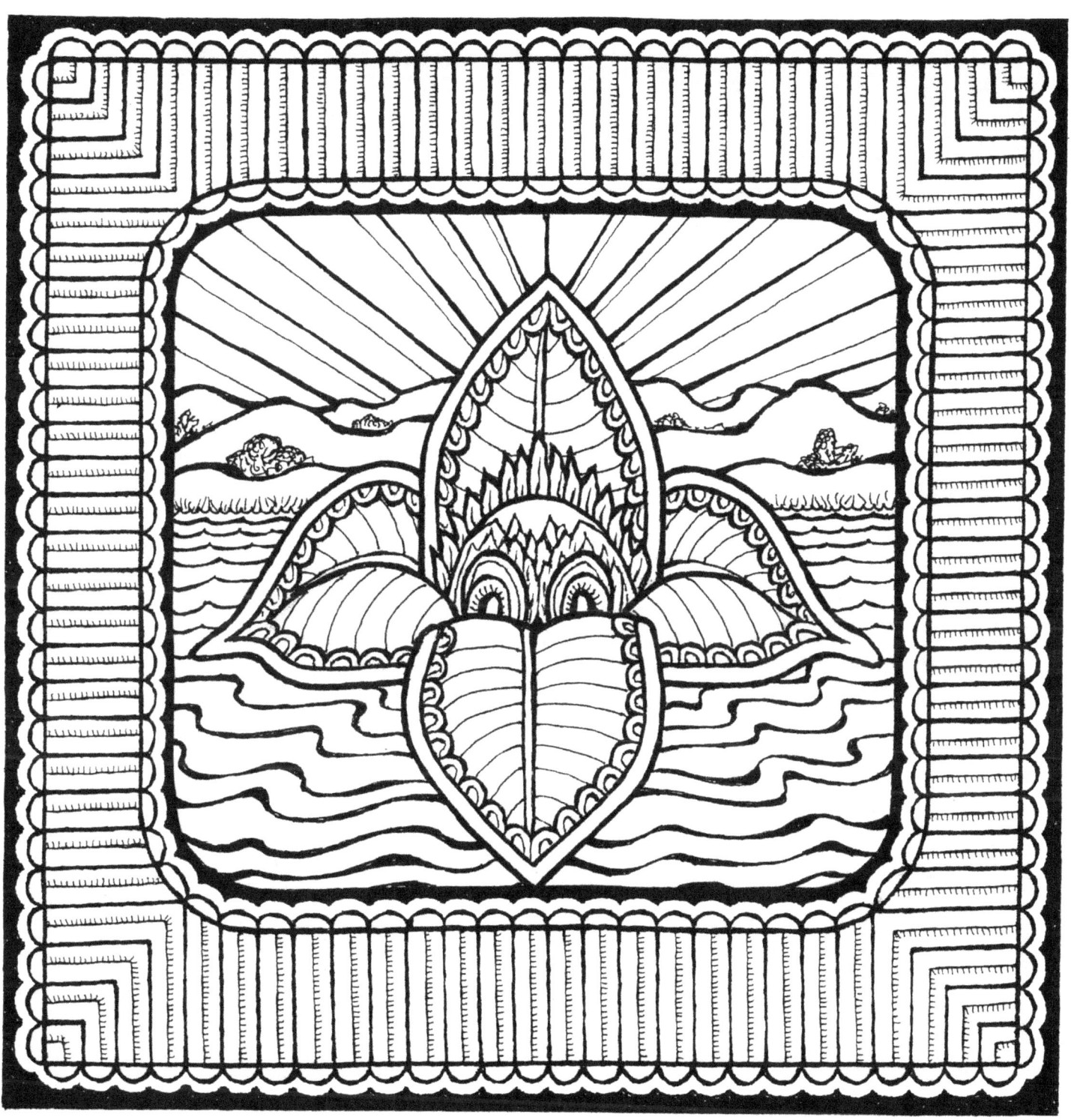

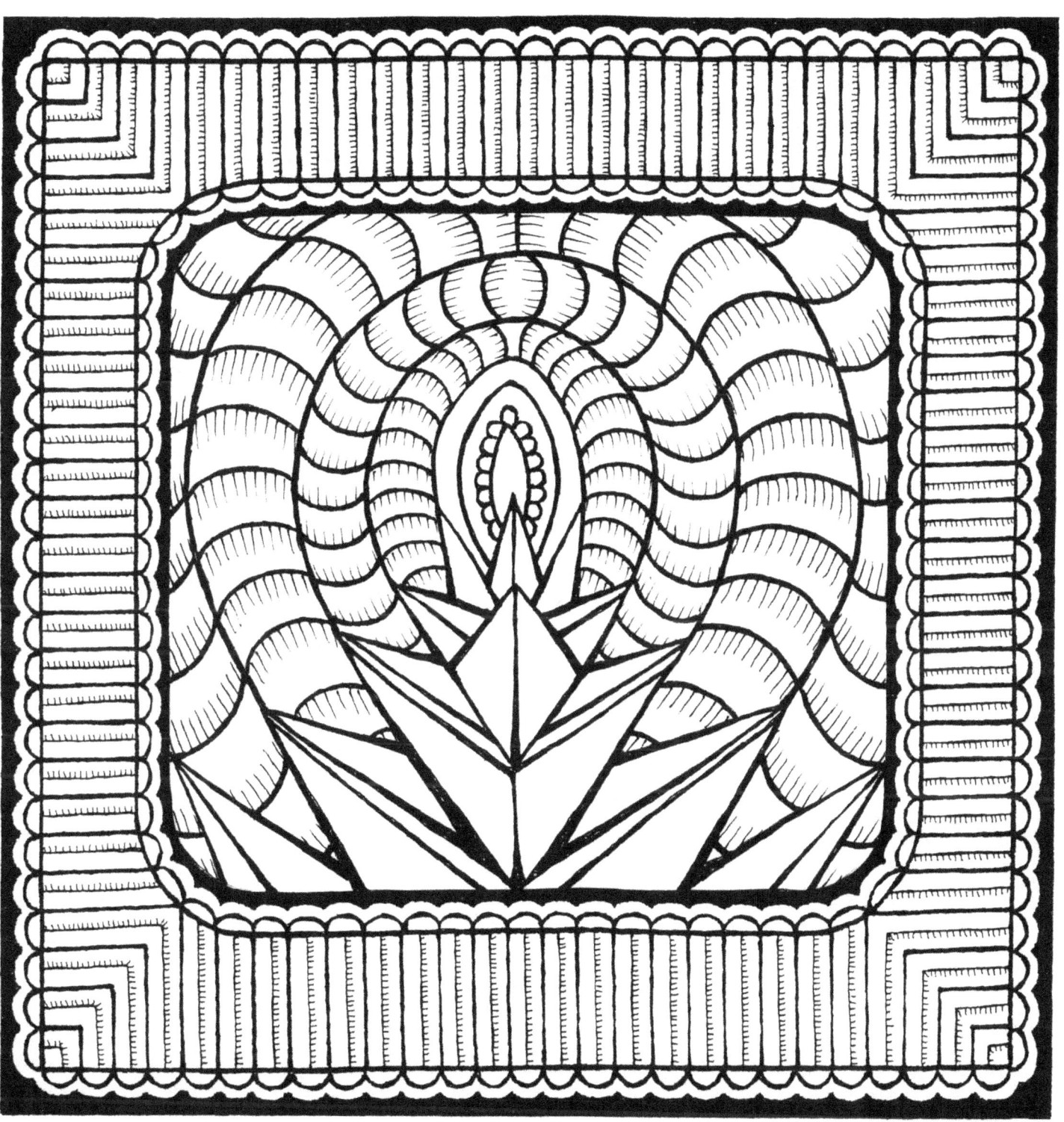

Books by Alberta Hutchinson

Home Made Books Coloring Books

Available from www.createspace.com (see specific web addresses below) and major booksellers:

MANDALA COLORING BOOK COLLECTION:

Mandala Designs Coloring Book No. 1 — 35 New Mandala Designs, (Revised in New Format)
www.createspace.com/4506373

Mandala Designs Coloring Book No. 2 — 32 New Mandala Designs, (Revised in New Format)
www.createspace.com/4555976

Mandala Designs Coloring Book No. 3 — 32 New Mandala Designs, (Revised in New Format)
www.createspace.com/4614672

Mandalas Coloring Book No. 4 — 32 New Unframed Round Mandala Designs,
www.createspace.com/5254882

Mandalas Coloring Book No. 5 — 32 New Mandala Designs, www.createspace.com/5298076

Mandalas Coloring Book No. 6 — 32 New Unframed Round Mandala Designs,
www.createspace.com/5365617

Mandalas Coloring Book No. 7 — 32 New Unframed Round Mandala Designs,
www.createspace.com/5385765

Mandalas Coloring Book No. 8 — 32 Intricate Round Mandala Designs, www.createspace.com/5479893

Mandalas Coloring Book No. 9 — 32 New Intricate Round Mandala Designs,
www.createspace.com/5479893

MORE HUTCHINSON DESIGN COLORING BOOKS:

Fantasy Flowers Coloring Book No. 1 — 24 Designs in Elaborate Oval Frames,
www.createspace.com/4446137

Fantasy Flowers Coloring Book No. 2 — 32 Designs in Elaborate Square Frames,
www.createspace.com/4485357

Fantasy Flowers Coloring Book No. 3 — 32 Designs in Elaborate Oval-Rectangular Frames,
www.createspace.com/5154200

Snowflake Designs Coloring Book — 24 Designs in Elaborate Frames, www.createspace.com/4446148

64 Christmas Ornaments Coloring Book, www.createspace.com/5186172

Make Your Own Book No. 1 — 50 Elaborate Round Frames for Coloring, with Text Lines,
www.createspace.com/4704942

Make Your Own Book No. 2 — 50 Elaborate Oval Frames for Coloring, www.createspace.com/4765016

Mantra Meditation Coloring Book, www.createspace.com/5589496

Lotus Lights Coloring Book—71 Intricate Pattern Designs, www.createspace.com/5761202 **Coming in Spring 2016**

Continued on the back...

Books by Alberta Hutchinson (continued)

OTHER COLORING BOOKS BY ALBERTA HUTCHINSON (available from major booksellers):

The Affirmations Colouring Book, by Louise Hay and Alberta Hutchinson, Hay House Publications

Mystical Mandala Coloring Book, Dover Publications

More Mystical Mandala Coloring Books, Dover Publications

Infinite Coloring Mandala Design CD and Book, by Martha Bartfeld and Alberta Hutchinson, Dover Publications

Creative Haven Square Mandalas (Creative Haven Coloring Books), Dover Publications

Creative Haven Lotus Designs (Creative Haven Coloring Books), by Alberta Hutchinson, Dover Publications

3-D Coloring Book - Mandalas, by Martha Bartfeld and Alberta Hutchinson, Dover Publications

Instant Zen Coloring Book, Skyhorse Publications, **coming in spring 2016**

Peaceful Mandalas Coloring Book, Skyhorse Publications, **coming in spring 2016**

Other Books from the Home Made Books Collection

Available from www.createspace.com (see specific web addresses below) and major booksellers:

ILLUSTRATED POETRY AND MEDITATIONS:

Fireflies, by Rabindranath Tagore, illustrated by Alberta Hutchinson (color version), www.createspace.com/5074812 (all proceeds donated to the Ninash Foundation)

Fireflies, by Rabindranath Tagore, illustrated by Alberta Hutchinson (black and white version), www.createspace.com/5070674 (all proceeds donated to the Ninash Foundation)

Songs of Symmetry, poems and art by Alberta Hutchinson, in full color, www.createspace.com/4019375

Doorways, 52 designs (including 24 doorways) in full color, with 13 black & white doorways for coloring, www.createspace.com/4389248

Night Drawings and Meditations, meditations and framed art by Alberta Hutchinson, in full color, www.createspace.com/5477788

My Palitana (India), story and art by Alberta Hutchinson, in full color, www.createspace.com/5423470

100 Meditations on the Sacred Healing Buddha, framed illustrations in full color by Alberta Hutchinson, www.createspace.com/4938232, (all proceeds donated to Free Tibet)

CHILDREN'S PICTURE BOOK:

The Orphan and the Christmas Tree, by Edward C. Colwell, illustrated by Alberta Hutchinson, www.createspace.com/3702633

NOVEL:

Step by Step, by Alberta Hutchinson, www.createspace.com/3669073

www.ingramcontent.com/pod-product-compliance
Lightning Source LLC
Chambersburg PA
CBHW082031190526
45166CB00017B/2821